TATTOO

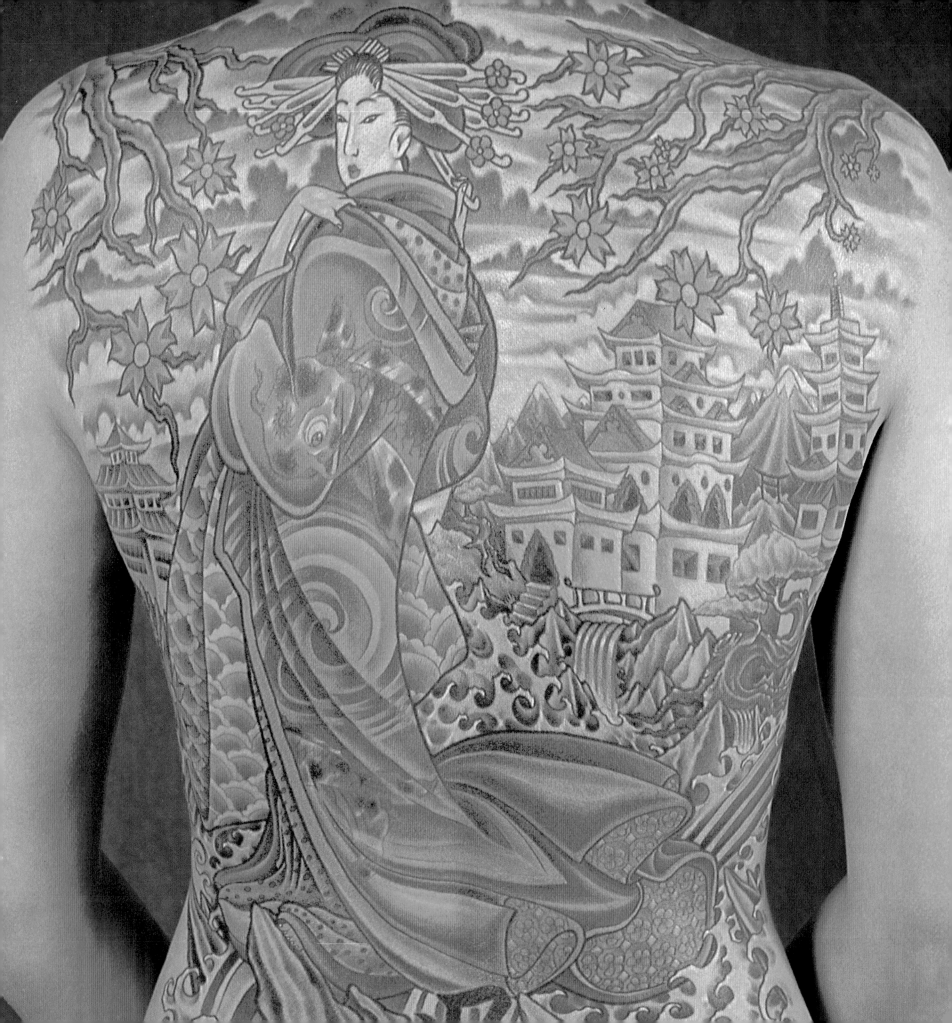

TATTOO

DALE RIO & EVA BIANCHINI

COURAGE
BOOKS

AN IMPRINT OF
RUNNING PRESS BOOK PUBLISHERS
Philadelphia • London

First published in the United States in 2004 by
Courage Books

Printed and bound in China

9 8 7 6 5 4 3 2 1
Digit on the right indicates the number of this printing

Library of Congress Cataloging-in-Publication: 2004107699

ISBN 0-7624-2011-1

Produced by
PRC Publishing Limited
The Chrysalis Building
Bramley Road, London W10 6SP

An imprint of **Chrysalis** Books Group

Published by Courage Books, an imprint of
Running Press Books Publishers
125 South Twenty-second Street
Philadelphia, Pennsylvania 19103-4399

This book may be ordered by mail from the publisher.
But try your bookstore first!

Visit us on the web!
www.runningpress.com

Jacket Acknowledgments:

Front cover, left to right, top row: © Dale Rio, © Doralba
Pincerno, © Dale Rio. Bottom row: © Doralba Pincerno.

Back cover, left to right: © Chrysalis Image Library / Simon Clay,
© Dale Rio, © Dale Rio.

Picture Acknowledgments:

The publishers would like to thank Dale Rio (www.dalerio.com),
Simon Clay, and Doralba Pincerno (www.doralba.com) for
contributing photographs to the book.

© Chrysalis Image Library / Simon Clay 5, 17, 18, 19, 22, 26, 29,
46, 58, 72, 73, 76, 77, 85, 86, 88, 93, 100, 101.
© Dale Rio 2, 7, 9, 10, 11, 12, 14, 15, 16, 21, 24, 25, 28, 30, 33, 36,
37, 38, 39, 45, 48, 49, 50, 51, 52, 53, 55, 56, 57, 61, 62, 63, 64, 65, 66,
67, 68, 69, 70, 71, 74, 75, 79, 81, 82, 83, 84, 90, 91, 92, 94, 95, 96, 97,
98, 99, 102, 103, 104, 105, 106, 107, 108, 109, 110, 111, 112, 113,
114, 115, 116, 117, 118, 119, 121, 122, 123, 125, 126, 127.
© Doralba Pincerno 6, 8, 13, 20, 23, 27, 31, 32, 34, 35, 40, 41, 42,
43, 44, 47, 54, 59, 60, 78, 80, 87, 89, 120, 124.

CONTENTS

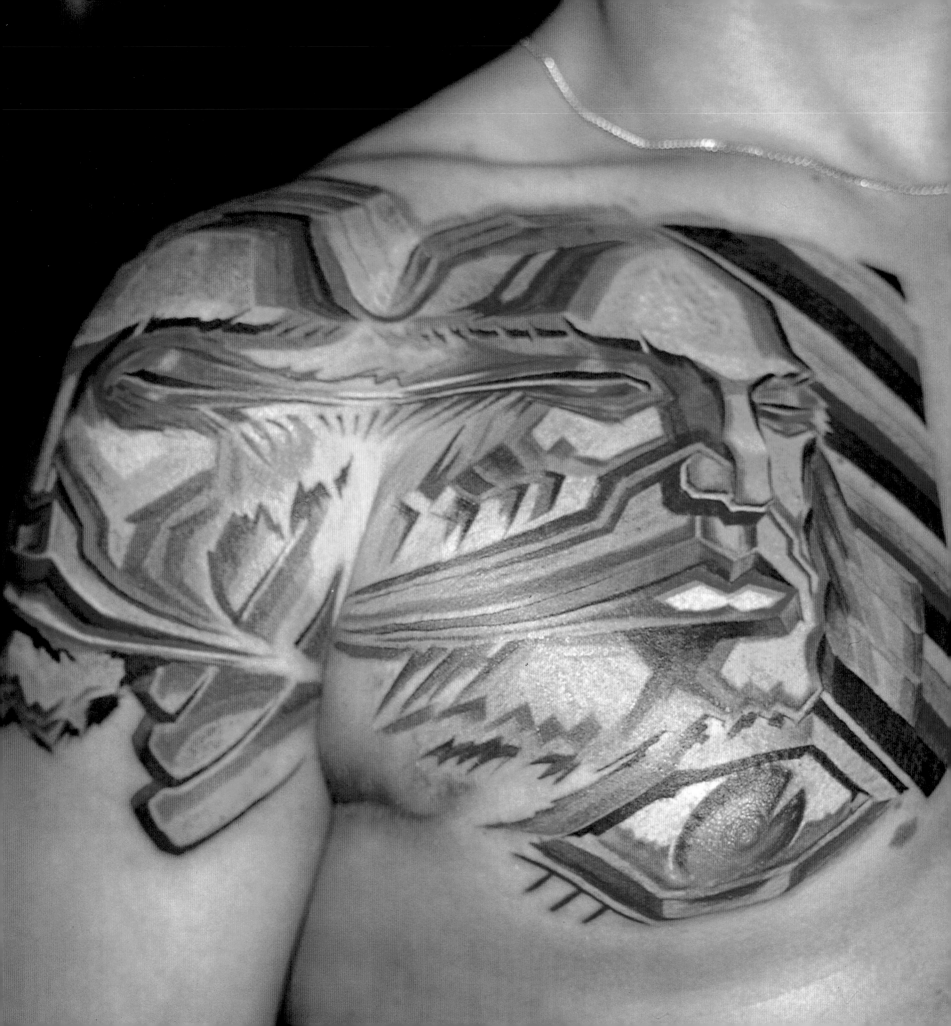

INTRODUCTION

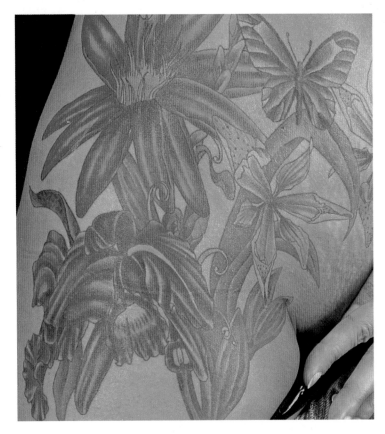

Above: Lisa Adams tattooed by Ken Lewis. This floral design extends across the stomach and leg and is complemented by a backpiece.

Left: Sergio by Waldi Wenner. This amazing tattoo shows just how the art has evolved away from standard "flash" designs in recent years.

"Tattooing has many facets, it's like a diamond. You can't see the facets from one view. You have to see it from all different angles. There is no formula to it. People get tattooed for different reasons. For some people, it's a mild rebellion. There is the peer pressure element. The word 'coward' has probably caused more people to get tattooed than any other reason. For some, it's a form of finding their lost tribal ancestry, so sometimes there is a cultural wave that causes a boom. Tattooing has changed radically over the years."

Lyle Tuttle—tattoo artist

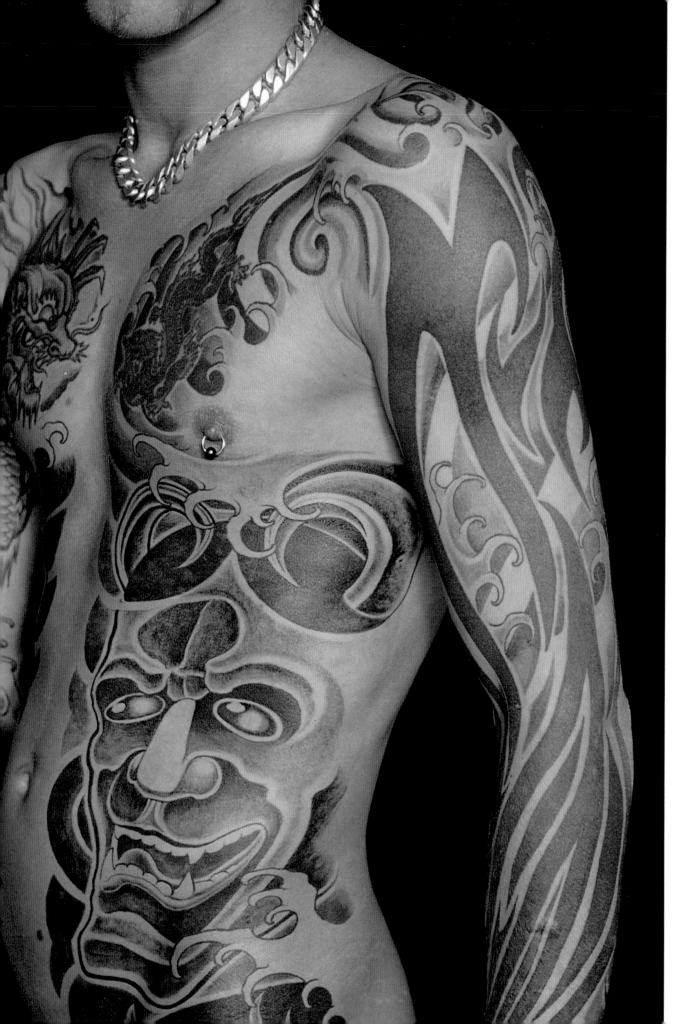

Left: Steffen by CTC, photographed at Berlin in 2001. Extending over the arms, torso, and legs this is quite major coverage, yet the consistency of the design work means that the tattooing works as a whole.

Right: Jennifer Chitwood tattooed by Josh Kilgalion. Inspired by Ink, in Columbus, Ohio. This tattoo is a contemporary take on a popular traditional sailor tattoo; the swallow. Such a reworking of older tattooing conventions is typical of New School artists.

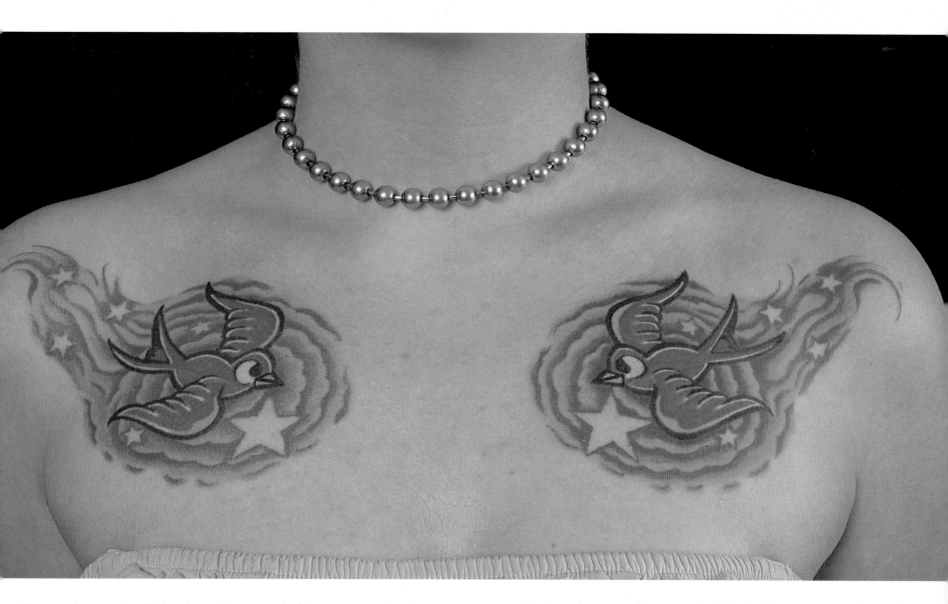

To pose the question, "What is modern tattooing?" is to pose a question with no single answer. It is true that tattooing has an extensively reported lineage and there is a wealth of literature on the subject available today, but to view any one book, article, or opinion as definitive would be naïve and incorrect. So many people, places, cultures, and events have marked the progression of the practice of ornamenting the skin with colored pigments that it would be impossible to define who was responsible for what style and when exactly it emerged.

The role of this book is not to tackle the enormous history of tattooing or give a comprehensive account of its current trends; to do so one would almost have to talk to every individual with a tattoo, so diverse are today's styles. What is offered here is an overview of contemporary tattooing and a look at the factors that have lead to its overwhelming popularity at present. This book is intended to introduce the reader to the world of tattooing with a little look at its history and the development of today's varying styles, together with some speculation about what the future might hold. The text accompanies some beautiful examples of contemporary work and provides a little practical advice for anyone feeling inspired by these images and are considering getting tattooed. Most importantly the aim is to encourage and provoke the reader to ask their

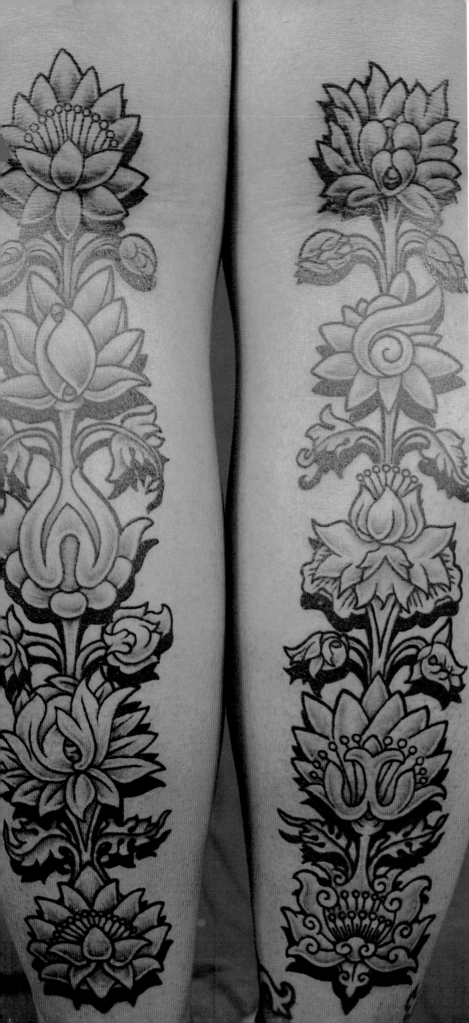

own questions and to look for their own answers about the art of tattooing. With an awareness of the possibilities, anyone contemplating a tattoo might get a piece of work that is truly original and reflects their own personality, rather than simply picking a "flash" picture from the wall of a tattoo parlor whose work would not suit their desires.

So, what do these tribal or primitive markings and decorations mean in a Western society? What drives Westerners to have tattoos inspired by those seen in the South Sea islands hundreds of years ago or in Japan or Egypt? What is the point of having Manga cartoon characters or ferocious beasts pricked into your skin? Why are so many people spending their time and money on having an artist inflict pain in order to have an indelible mark upon their body?

The answer to this is to imagine the body as a canvas, an artistic space to mix and match physical and cultural elements in defining who or what you want to be. It seems young Westerners have appropriated once underground practices to gain entry into a trendy club, with the tattoo a prerequisite at the door. Unlike the physical and symbolic violence of initiation rites in traditional societies though, these bodily alterations are the result of a conscious personal choice; literally wearing your heart on your sleeve. Or as you will find throughout this book, right across your chest.

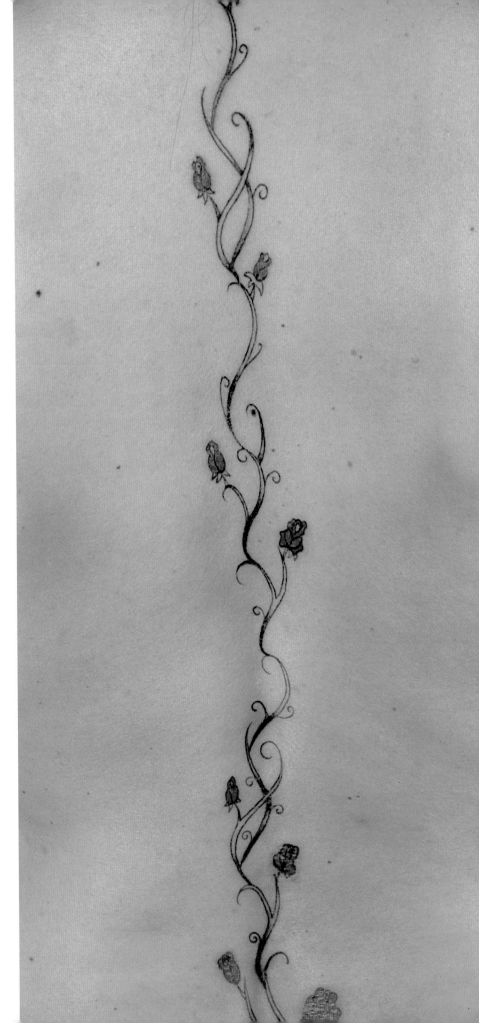

Of the millions of people who flirt with body decorating, the vast majority are fulfilling the desire for self-knowledge and recognition from others. There is, however, a paradox in this. From such a personal and permanent form of art one would expect to see a constant originality and innovation. In fact, the world of tattooing is something of a melting pot, drawing on body-altering techniques and styles long used by ancient cultures for purposes of religion or identity and still using styles that have been in vogue for decades, centuries, even millenia. They might now invoke aesthetics, spirituality, sex games, or the desire to belong to a group, but whatever the reason, the process of altering the body and putting it to the test comes down to playing with identity.

This reflects a profound change in Western culture, and a relatively recent one. The urge to assert oneself goes hand in hand with a desire to challenge social norms and values, and to advocate different ways of experiencing, feeling, and displaying one's body. Many fans of body art, piercing, and tattooing say they no longer accept the Western ideal of physical perfection that is forced down their throats by movies, TV, and magazines. While shooting a TV documentary, the tattooist Alex Binnie was asked why he chose to have the arch angel Gabriel tattooed on his back. In response he offered this immortal line, "Because I'm turning my body into an icon." It seems this is what we are all striving for—a sense of

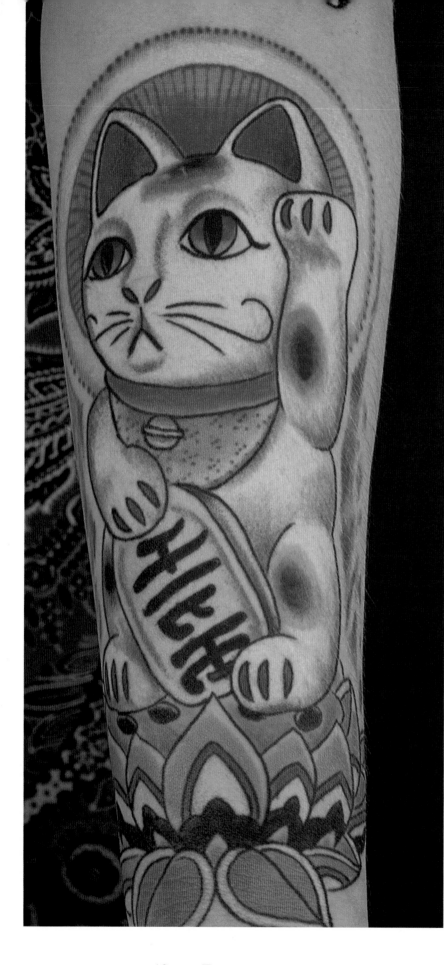

our own uniqueness, to make our mark… and in these days of mass markets and popular culture if we can't do that within our own society perhaps all that's left is our own skin.

This is a very exciting time for tattooing. Not only has it gained social acceptability in Western society, but the advances in inks and machine technology have made virtually anything possible. For as many people as there are making and collecting tattoos, there are as many styles. Collectors are moving away from simply picking flash designs off the wall and are having their tattoos custom designed by their tattooists. There are people who prefer the tried and true traditional tattoo styles, whether it be traditional American (or sailor style), Japanese, or tribal, and study the techniques and design meanings with the masters and old-timers. There are people who use traditional motifs as a starting point and incorporate their own particular vision into accepted subject matter. There are tattooists doing life-like portraits and wildlife scenes. And then there are people exploring new areas of tattooing, utilizing styles normally relegated to other artistic media, be it comic book art, graffiti-inspired work, cubist painting techniques, biomechanical or biomorphic artwork, or any other style historically restricted to painting or drawing. Collectors feel confident that no matter what they want to get tattooed on them, there is an artist who specializes in what they're looking for; if they want a portrait of their

Right: Armelle by Final Tribal, Valladolid, Spain. A splendid work of custom tattooing that draws inspiration from both Japanese style and tribal tattooing.

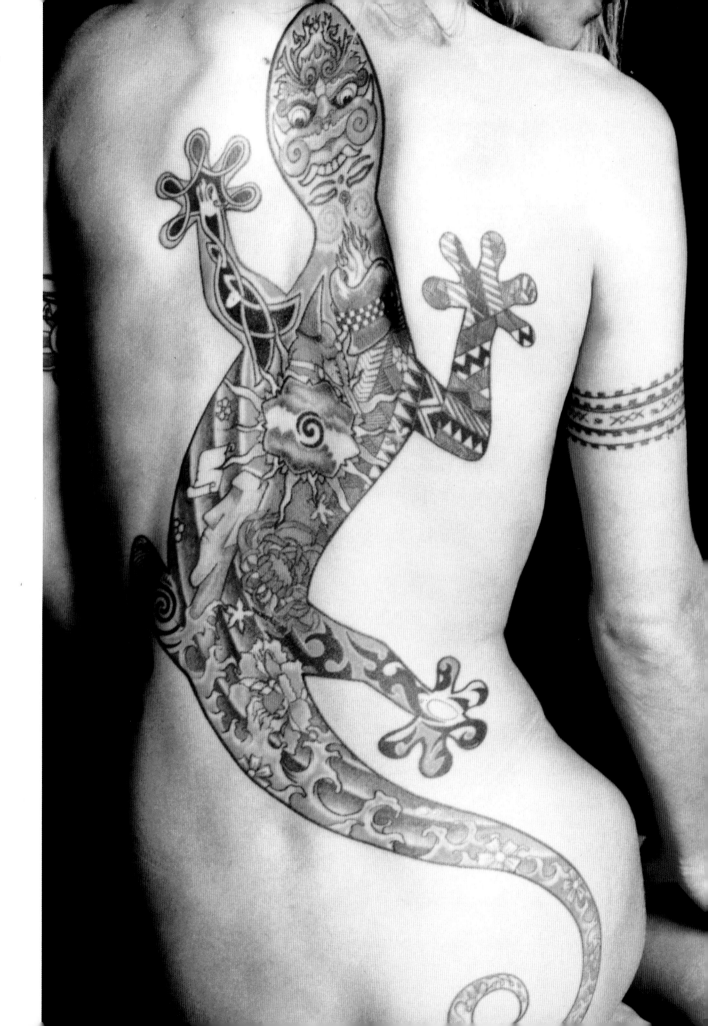

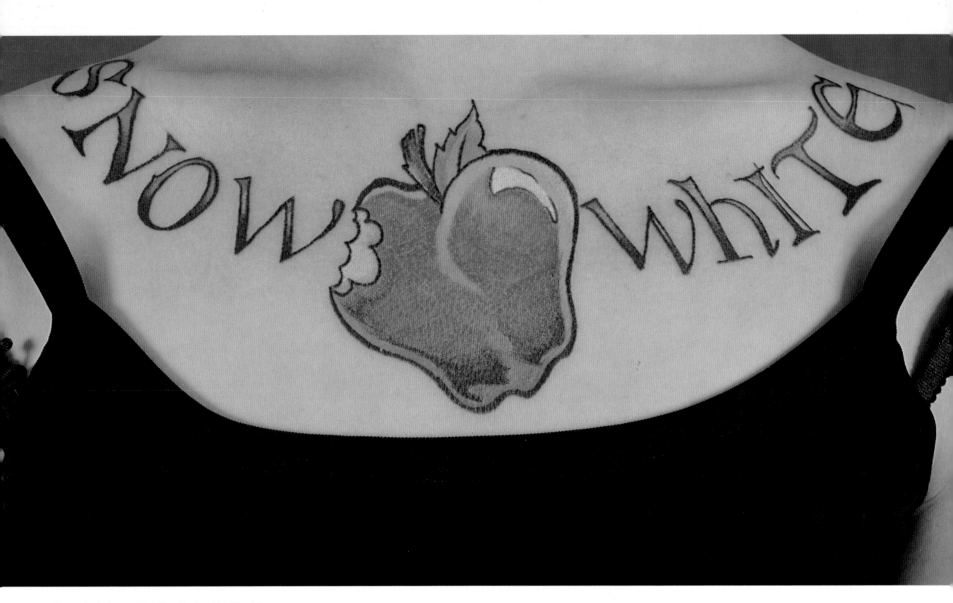

Above: A design on Kat Day by Frankie D., of the Tattoo Emporium, Florida. The use of lettering in tattoo work was very popular in traditional tattooing and, as with these images, this has been revived with a modern twist for a new generation.

mother copied faithfully, an event in their life represented symbolically, their favorite painting reproduced or book interpreted on their body, or if they want delicate black and gray wash or vibrant colors, there is someone who will happily fulfill their vision.

There are iconographic tattooists whose names are synonymous with the style they specialize in: say the name Paul Booth and people automatically think of dark, heavy, demonic scenes; Leo Zulueta translates to bold, large-scale, black "tribal" tattoos; Jack Rudy pioneered the East L.A. black and gray script styles; Tom Renshaw is the man to go to for photorealistic work; Guy Aitchison specializes in biomorphic, painterly

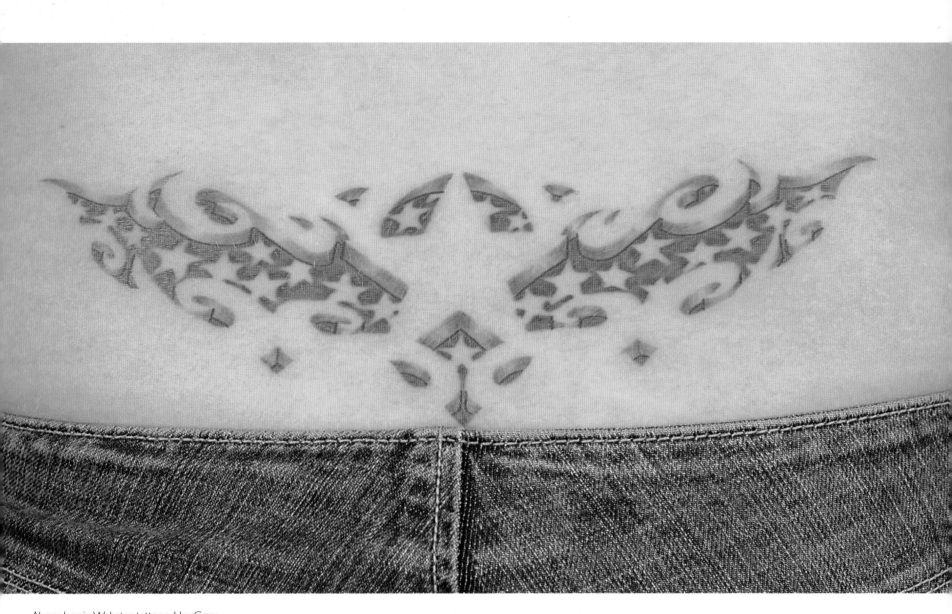

Above: Jennie Webster tattooed by Cory Ferguson, Way Cool Tattoos, Oakville, Ontario, Canada. Like many tattooists Way Cool still offer a large selection of flash tattooing, but are proud of a team that can offer a broad range of styles for those seeking a customized tattoo. This piece is simple but effective, and takes stars as its theme.

pieces. There are scores of exceptional, younger tattooists, in their twenties or thirties, focusing on the time-tested traditions as well as developing their own personal style.

The observations and photos in this book are by no means the be all and end all of what is going on in the world of tattooing today; they're restricted to the cities that the photographers have visited and to those tattooists who attend tattoo conventions. We realize that there are many top artists who don't work conventions, and unless we've heard of them through other channels, our access to them is limited. Our apologies in advance to anyone who may feel like they've been overlooked.

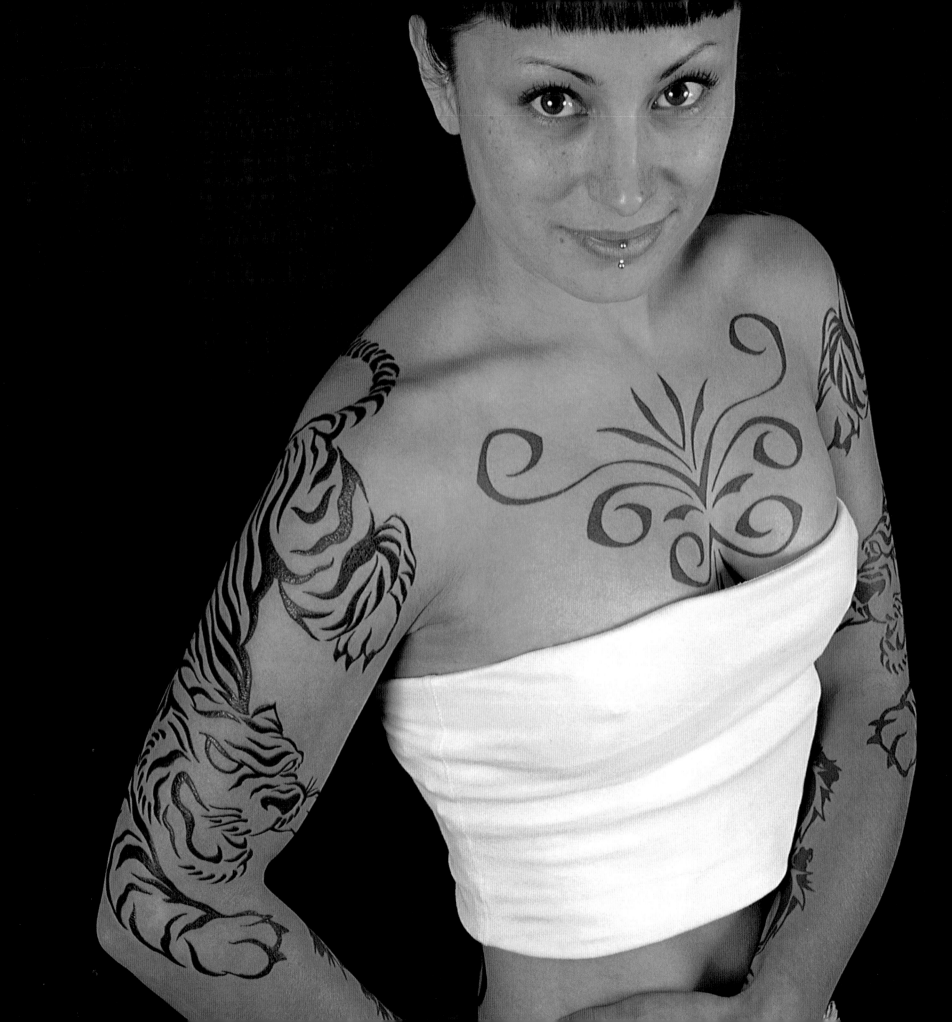

THE LINE TO THE PRESENT

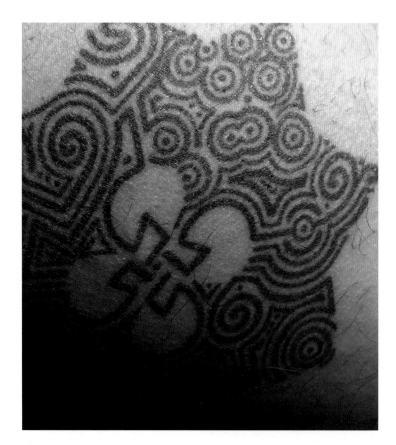

Above: An abstract blackwork design which takes its inspiration from ancient tribal tattooing. Such work became fashionable from the beginning of the 1990s and is still immensely popular.

Left: Lisa M. Duhl tattooed by Matt Victor. Lisa has symmetrical blackwork designs on her upper body, including tigers going from each shoulder down her upper arms.

Tattooing is everywhere in today's society, with people from all walks of life being inked in a vast array of styles. Skateboarders, supermodels, punks, businessmen, mothers… where once tattooing in the West was the preserve of circus freaks or those on the far fringes of society, now there are very few demographics where tattooing is disdained. One estimate suggests that in the U.S. alone, one in seven people has a tattoo. Not all are obvious—while some wear their tattoos very publicly, many more prefer subtle work that only a few will know about.

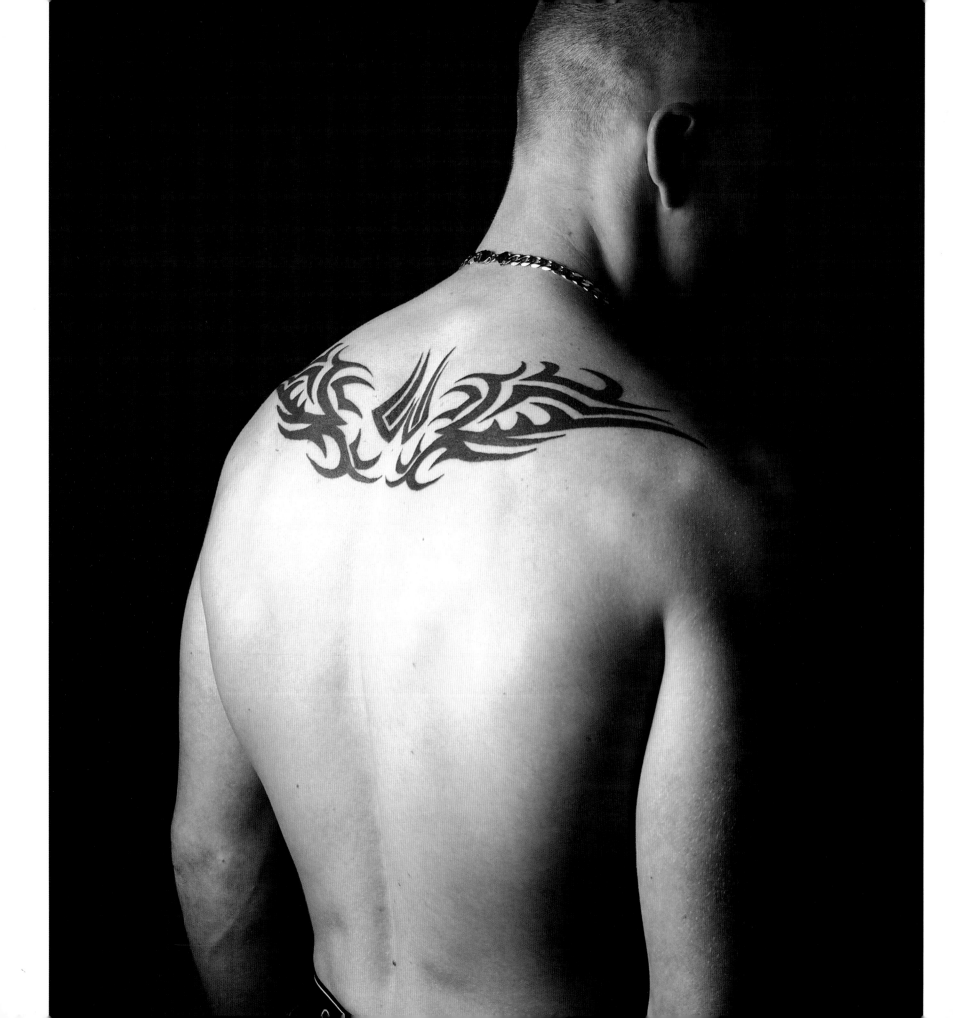

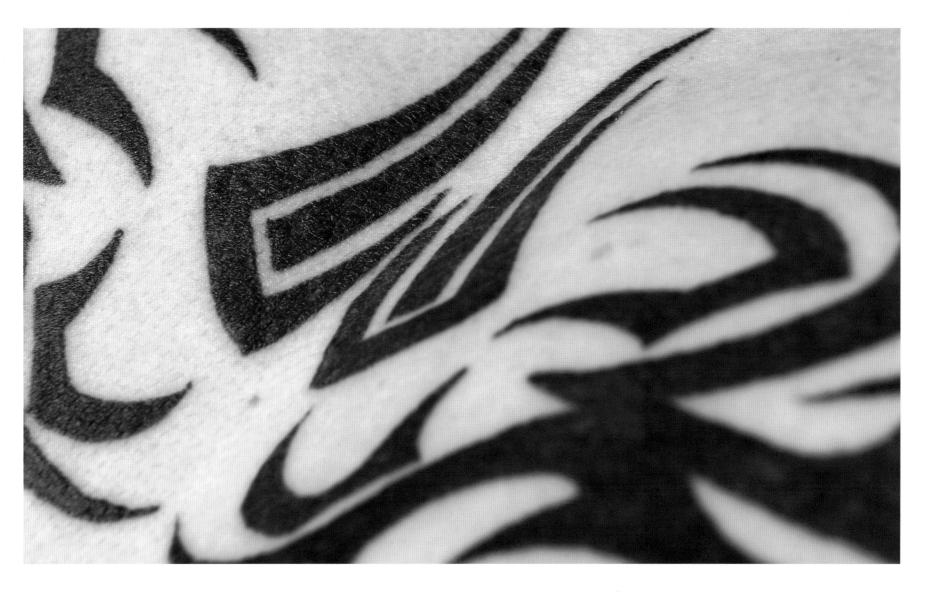

Left and Right (detail): This tattoo by Simon Read at Scribe Tattooing, in the U.K., is representative of a lot of today's tattooing. Influenced by both Celtic and tribal work, it is simply an attractive design that suits the wearer. The shoulders are one of the most popular areas for a tattoo.

Whatever the tattoo is and wherever on the body the collector chooses to have it placed, however, it seems that there is a growing awareness of what is possible with tattoo art. There is a proliferation of tattooists, many of whom are considered masters of the art, celebrities in their own right, with clients booking months in advance and crossing continents in order to get a piece of their work. The art of today's best tattooists might combine traditions from around the world with their own style to lesser or greater degrees, creating a modern body of tattoo art around the world that is

The Line to the Present | 19

phenomenally creative. From Los Angeles to Sydney, London to Berlin, tattooing is enjoying a popularity unthinkable a few years ago. Barriers of gender, class, and wealth have also been breached. Today, one is just as likely to find a wealthy young female socialite with a fine tattoo as anyone else.

With such a dynamic modern scene it would be easy to think of tattooing as a relatively modern concept. However, it is valuable to remember that the art is as old as civilization itself and even a brief look into its history is worthwhile for anyone who either has or is considering a tattoo. In fact, to have a tattoo is to be a part of a story that stretches back thousands of years. A tattoo connects the owner to a lineage that includes people from all over the world and throughout human history, from Siberian princesses to American circus performers. And it's amazing how relevant the millennia of tattoo history is today. For example, though we may not now mark criminals with tattoos or view them as inherently evil (though it's arguable that this legacy lives on in the fear that some people feel when meeting a tattooed person), there is still something of an "outcast" connotation to the tattoo.

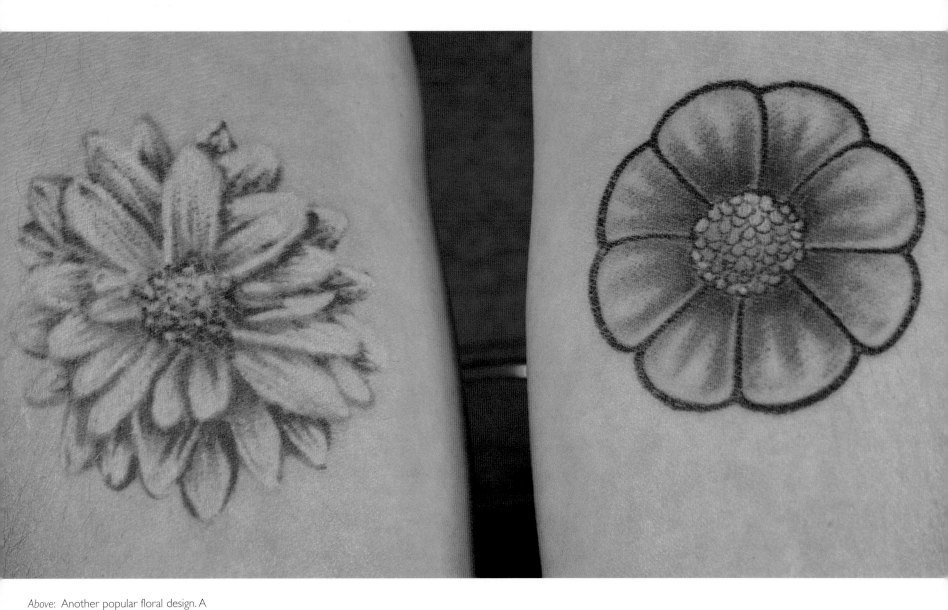

Above: Another popular floral design. A revolution in tattoo designs has meant that tattooing has cast off many of its old connotations. Art such as this has come a long way from the days of anchors and swallows, and tattoos are now just as likely to grace a model as a sailor.

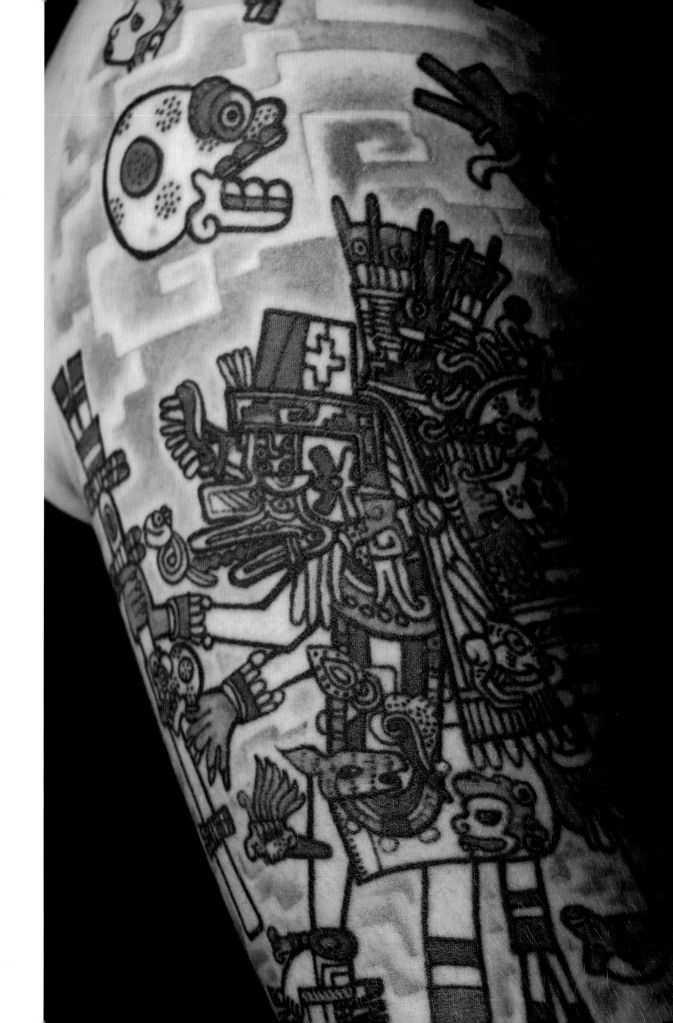

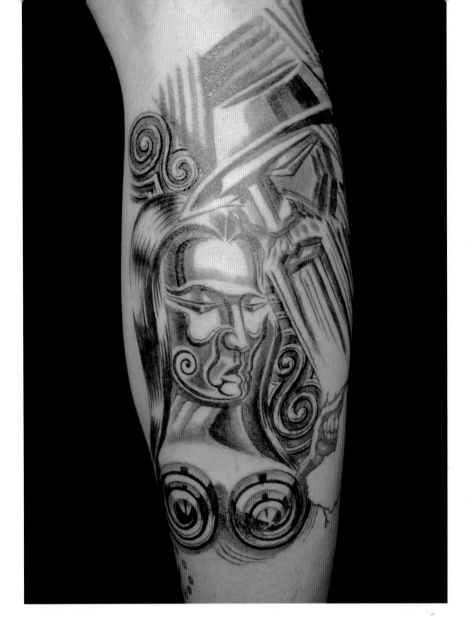

Right: Mike by Waldi, photographed at Barcelona 2000. This stunning piece of work takes its inspiration from the work of abstract art.

Tattooing and other forms of body modification such as piercing and scarification are inextricably tied to human concepts of aestheticism and identity. Such practices are part of overall body decoration and adornment, which are similarly illustrated by costume, hairdressing, and cosmetics. All of these forms of personal expression are rooted in the individual's idea of social conformity and affiliation. They symbolize a commitment to a group or a concept and are a visible sign of that commitment, whether the tattoo is worn loud and proud by a biker, or as a secret sign of gang membership.

Since tattooing appears to have developed simultaneously worldwide, in such far-flung places as Peru and Egypt, it is unlikely to have been spread by migrating peoples, though this is a common theory. From what can be gathered through archeological evidence, it more probably developed as a reaction to the circumstances affecting the peoples who first began to tattoo themselves. Although there are convincing arguments for tattooing being over 10,000 years old, the earliest known firm evidence dates back to ancient Egypt where records of tattoos can be reliably traced back 4,500 years (around the time of the great pyramid building), though it would seem obvious that tattooing was first practiced even earlier than this. The oldest preserved tattoos from this period are from Thebes, during Dynasty XI, about 2,160 years ago. These tattoos are from a preserved

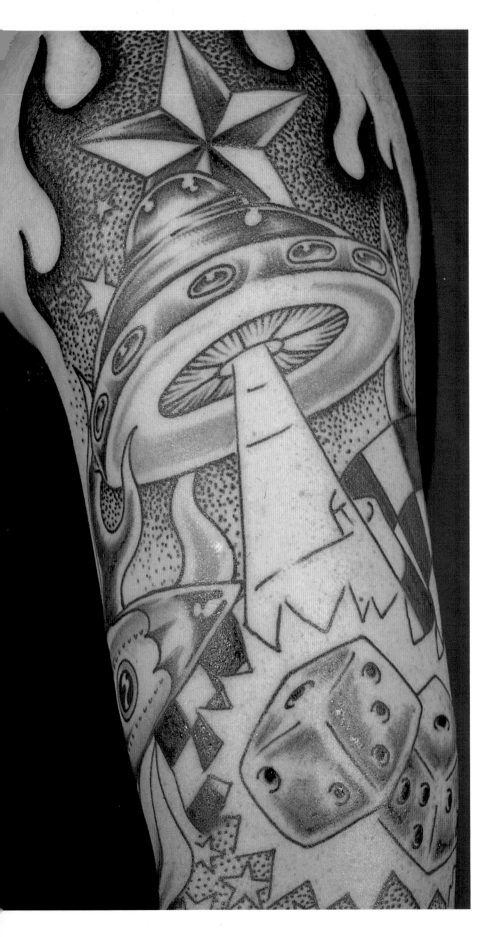

mummified female and comprise of a series of "abstract patterns of individual dots or dashes randomly placed upon the body." The earliest tattooed Egyptian mummies are of people who seem to have been associated with Nubia, and indeed, Nubian mummies discovered in Kubban and dated to 2000 BC, display similar tattoos to the Egyptian finds. More recent excavations at Aksha uncovered tattooed mummies of both adolescent and adult women with similar tattoo patterns, but at a much later date of 400 BC.

It is significant to note that most early examples of tattooing are on women, which shows a distinct mind-shift through history, as until recently tattooing had become associated with men. In short, tattooing may once have been the sole preserve of females. The women of today who are being tattooed with as much confidence as men are simply reclaiming their heritage!

The motivations behind the tattooing of indigenous people are as varied as the races themselves. Anthropologists have in the past suggested that some tattooing from the period in Eygptian history known as the "Middle Kingdom" (about 2000 BC) may have had erotic overtones. There may be connections between the tattoo traditions and the goddess Hathor "the most lascivious of all Egyptian goddesses."

Right: Casey Romey tattooed by Durb Morrison and Dave Ski at Stained Skin, Columbus, Ohio.

However, contemporary opinion differs on this view of the ancient world. Clay figurines found from that period show decorations of dot and diamond-shaped patterns often interpreted as tattooing, though they may in fact be body painting or scarification. Such decoration may have been more to do with vilifying enemies than the glorification of sexuality. Some have interpreted these figurines as a depiction of the divinity Bes, associated with the household and employed as a protective talisman.

Elsewhere in Asia, Scythlan bodies from frozen burial mounds in Southern Siberia were recovered with elaborate and extensive tattooing. At Pazyruck, bodies of a Scythian "princess" and "chieftain" have been excavated. The pair date back over 2,500 years and have patterns of tattoos that are highly elaborate. Natalie Polosmak, the excavator of the "Princess" speculates that, "the tattoos may contain some kind of code. They may say something about her life." Body art, then as now, is more than just decorative.

In Japan, tattooing was known by 600 BC. Clay figurines from the Jomon (c. 10,000–300 BC) and Yayoi (c. 300 BC–300 AD) periods show markings which have been interpreted as either facial tattoos or scarification. Also from the Yayoi period, a reference from Chinese dynastic histories compiled by Chien Shou in 297 AD refer to the inhabitants of

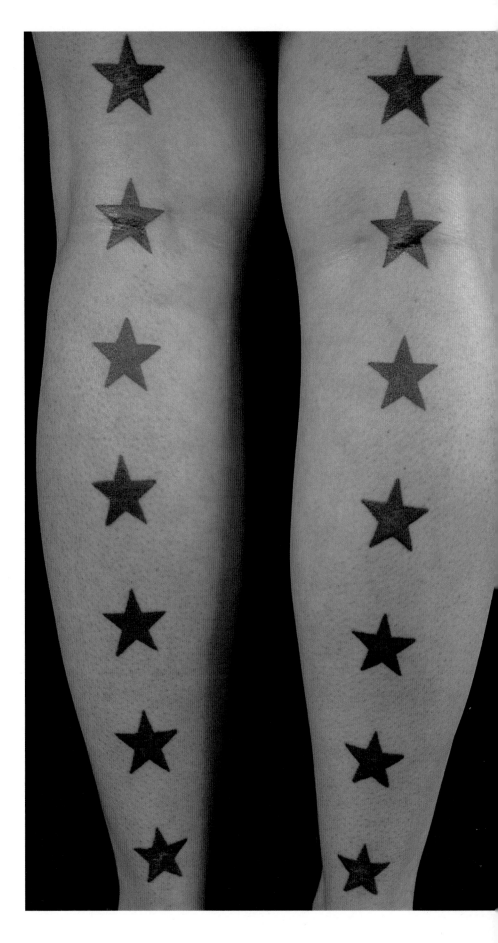

Left: This tribal tattoo on the ankle and foot is evocative of original designs that have been used in the South Pacific since time immemorial. The use of this style in the West was pioneered in the early 1990s by a group who wished to display a connection to a more environmentally harmonious culture.

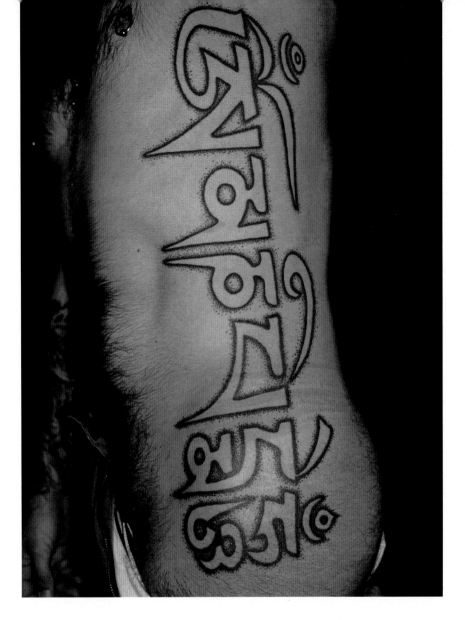

Right: In a similar way to tribal tattooing, this Tibetan mantra connects the wearer to an ancient spirituality.

Japan: "Men, young and old, all tattoo their faces and decorate their bodies with designs." The account further states that tattoos had protective functions and that the position and size of tattoos varies according to the rank of the individual. Later, it is reported that Japan increasingly followed China in the custom of using tattoos as caste or punishment emblems with those of low rank, untouchables, or criminals so marked to confirm social ostracism. Of course, tattooing as punishment became a vicious circle. The tattooed criminals would never again be fully accepted by society and many abandoned all hope, sinking into further crime. Consequently, the penal system formed a solitary minority group, known as the eta class who were

social outcasts and a person with a tattoo was generally feared by society at large.

The decorative traditions which we now associate with Japanese tattooing developed much later—in the seventeenth century—though they are still associated with the Japanese underworld, the Yakusa. Conversely, in the West, Japanese-style tattooing is regarded as high art and tattoos in the Japanese style are highly sought after.

Moving across Asia and into Europe, an "ice man" found in the Austro-Italian Alps in 1991, possibly dating back some 2,500 years, represents another example of some of the earliest archaeological

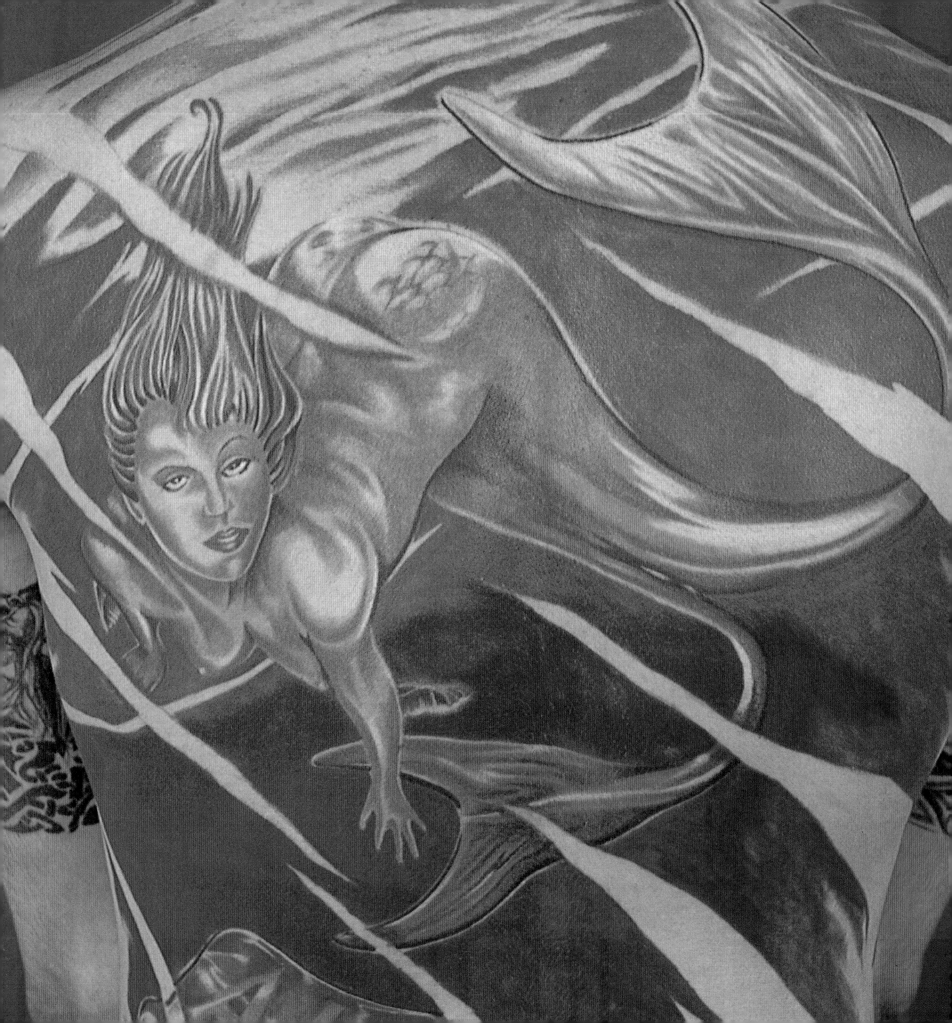

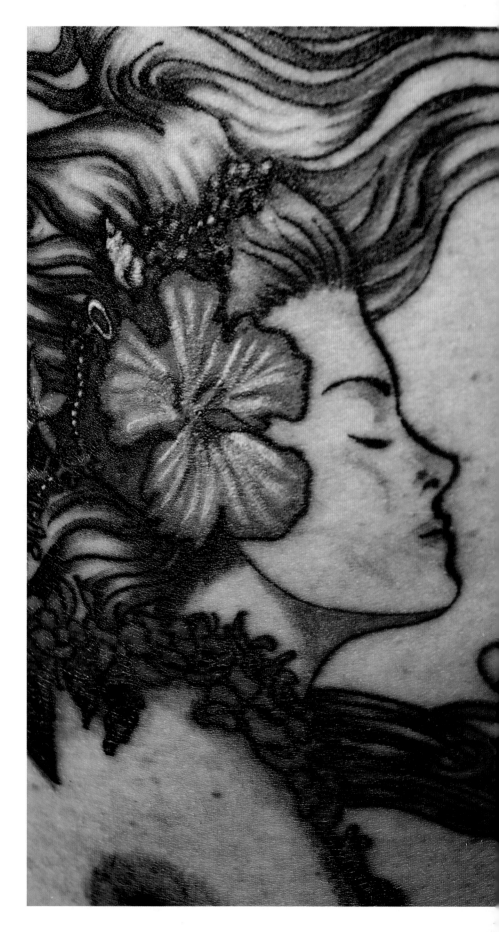

Left: Richard Serena tattooed by Fabrice, Screaming Needle, Lyon, France. Mermaids were another motif often seen in traditional Western tattoos, due to the popularity of tattooing among sailors.

Right: Jez by Simon Read at Scribe Tattooing. This style is more directly connected to the Western tradition, though its execution is more thoughtful and delicate than would have been usual in the past.

evidence for the practice of tattooing. In this instance it is believed that the tattooing has strong talismanic connections. The "ice man" had a series of bands tattooed around his knee and elbow joints and could be interpreted as protection against the effects of disease or misfortune.

In Europe, very early body art was arguably practiced by, among others; Ancient Britons, Thraciens, Gauls, and Germans. In Greece there is mention of the art of tattooing in works by writers such as Cicero and Herodian. The Romans too had an interest in tattooing, with great authors such as Virgil, Seneca, and Galenus reporting how criminals and slaves were marked as a stigma. There are also reports from Roman authors that groups such as the Picts were tattooed or painted, though this may in fact simply be a case of the authors attempting to depict Rome's adversaries as savage or criminal in nature; there is little actual evidence that the Picts were tattooed.

Early Christians tattooed a cross on either their arms or face (much as Coptic Christians in Armenia, Abyssinia, Syria, and Russia do today). However the tradition fell out of favor in the West and, rather strangely given the nature of the markings, even came to be considered a sign of paganism. Later still, any tattooing on the face was forbidden by Emperor Constantine and in 787 AD, a Council of Churches meeting at

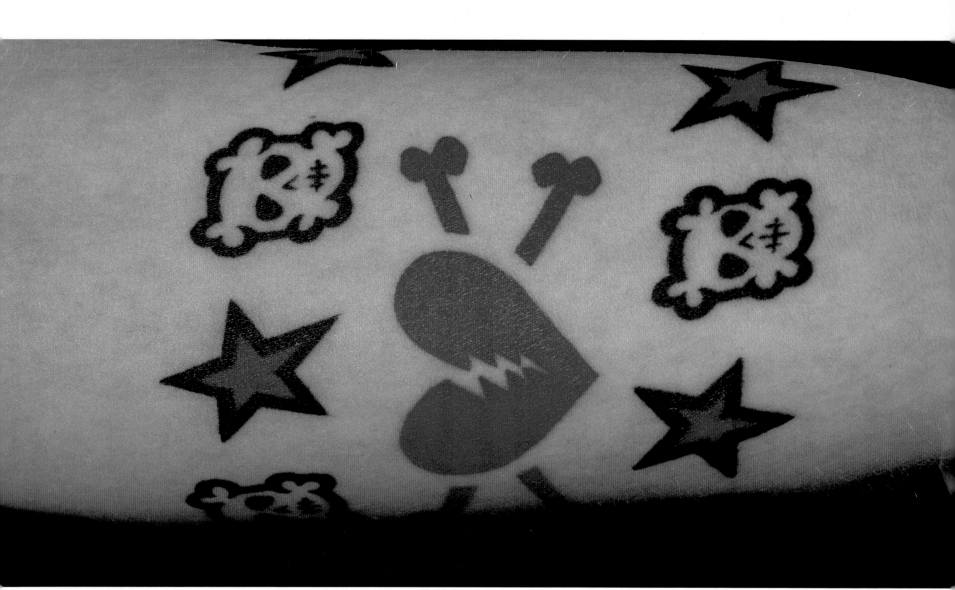

Calcuth in Northumberland, England, prohibited all forms of tattooing anywhere on the body.

At that time the power of the church across Europe was consummate and this edict gave rise to suspicion of anyone with a tattoo. They were viewed as outside of society or even evil. From this time in Europe tattooing was rejected, and abhorred and began to decline "almost to a point of disappearance during the Dark and Middle Ages in Europe." It would be centuries before the art again found some kind of acceptance.

In fact, the history of modern tattooing in Europe, and subsequently America, can be traced back to the first adventures into the South Pacific, and especially the voyages of Captain Cook in 1769. Cook, having visited Polynesians with a rich tattoo culture even brought back the word "tattoo" (derived from the Tahitian *ta tau*, "to mark"). On his return to England, Cook described the traditions and tattoo patterns of Polynesia with accuracy and enthusiasm, and generated considerable interest across Europe.

Western notions of body art were colored at the time by the idea of the "painted savage." Into this category now came the tattooed sailor, the first Westerners ever to be influenced by Polynesian tattoo culture. These European sailors and adventurers whose enthusiasm for tattooing

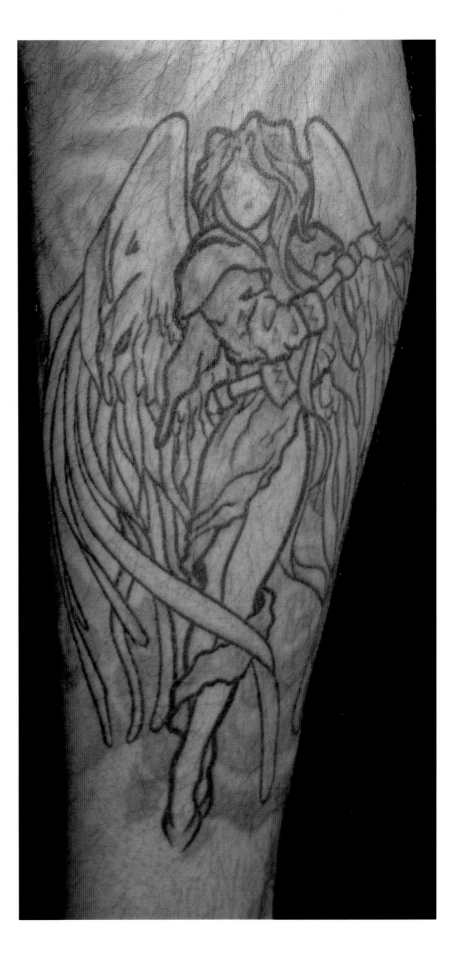

Left: Ryan Hardwick tattooed by Justin Urban-Style, Atom Bomb Tattoo, Willoughby, Ohio. This very contemporary design was executed by a tattoo parlor that now only undertakes custom work, producing a personalized tattoo for each and every client.

Right: Mario by Massimiliano, photographed at Rome 2003. As with the tattoos on the previous pages this piece can trace its ancestry back to "sailor style" designs of previous generations. However, it has a very modern feel, more akin to the artwork from a graphic novel than a traditional tattoo.

surfaced during their very first encounters with Polynesian culture, employed this form of decoration spontaneously as an "expression of class position, lifestyle, or the mariners habitués." These, then, were the first people in the West to wear a tattoo as art, and in order to express themselves.

In the island societies from whence it came, tattooing was the norm and played a "key role in the construction of the person." In Tahiti for example, women may have been tattooed to indicate that they had a certain skill, such as weaving. The tattoo would have been a visible symbol of her prowess and would have made her much more attractive as a

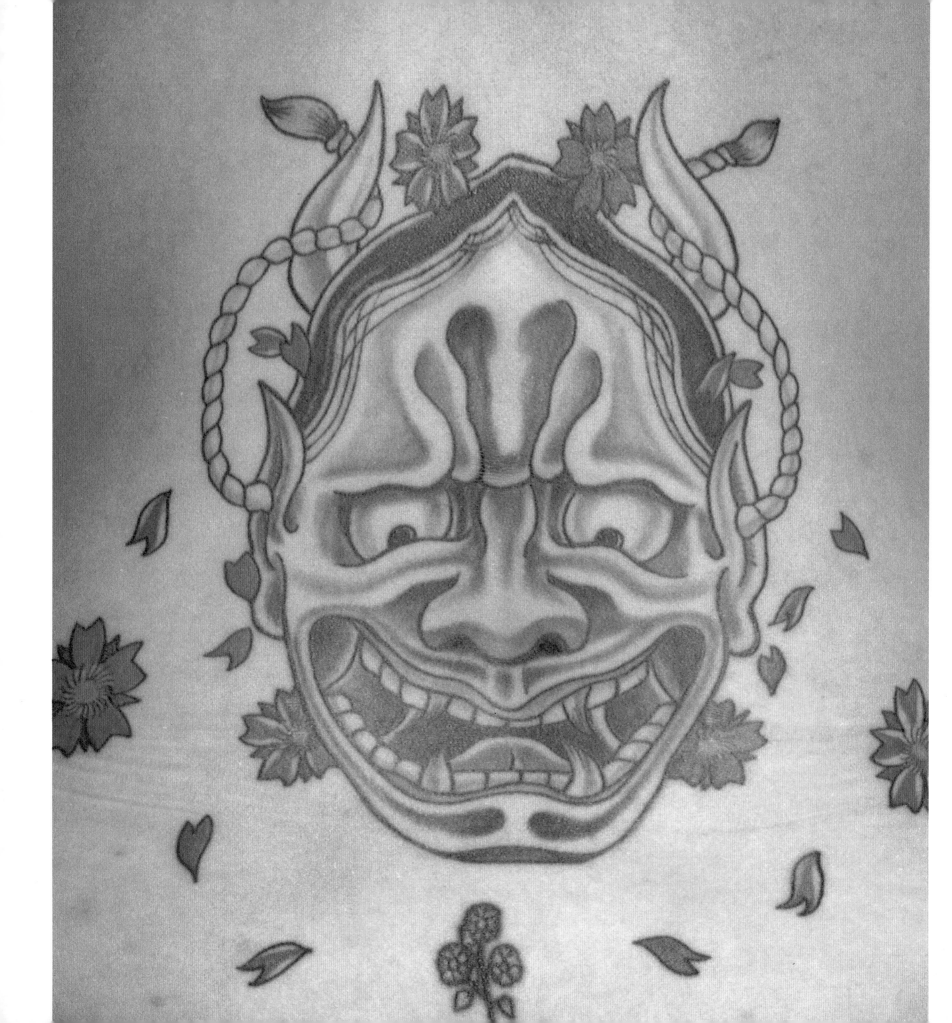

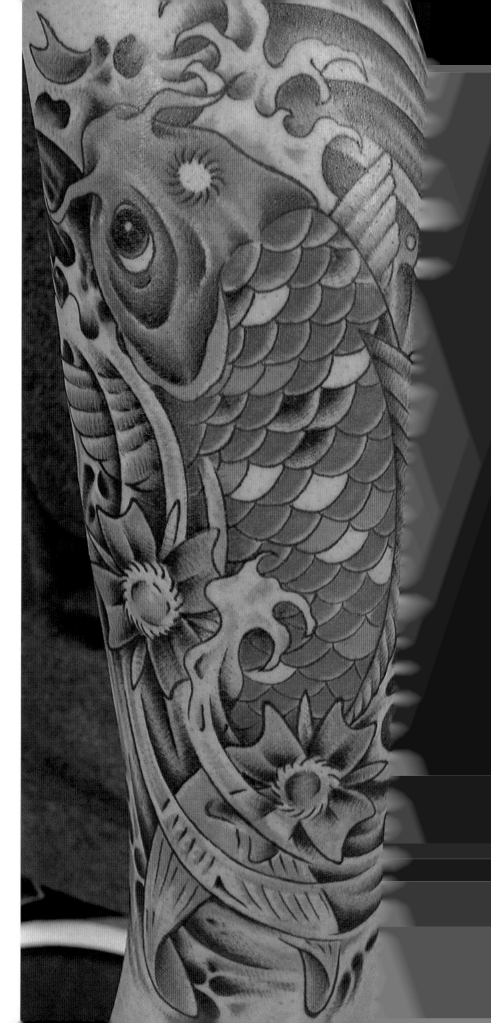

Left: Sandrijn by Marco Bratti, photographed at Berlin in 2002. This playful design takes its inspiration from Oriental mythology.

Right: The carp is a common motif in Japanese inspired tattoos.

marriage prospect. In Polynesian countries such as Hawaii, New Zealand, the Marquesas, Samoa, and Melanesian Fiji, the people, while not sharing a cultural reason, exhibit a strong similarity as body art is used as a means of expression and communication within society.

Back in Europe, although tattooing was now becoming increasingly popular with the lower classes it was still generally frowned upon in "polite" society in both Europe and the United States. In the mid to late nineteenth century however, for a short period, tattooing was considered the height of fashion among European nobility. Edward VIII, the Czar Nicholas, King Frederik of Denmark, and the infamous Prince Constantine of Albania, among others, were decorated and a discreet tattoo was considered *de rigeur* for men.

In 1891, the first electric tattooing machine was patented, and this development effectively revolutionized the tattooing process. Prior to this all tattoos had been executed by time-consuming hand techniques. Tattooing at this time was mainly the preserve of traveling artists, with information on techniques often circulating via an "underground communication network." This new technological advancement more than any other, before or even since, had a profound effect upon the style and the possibilities of design. In fact, the simple tattoo apparatus is

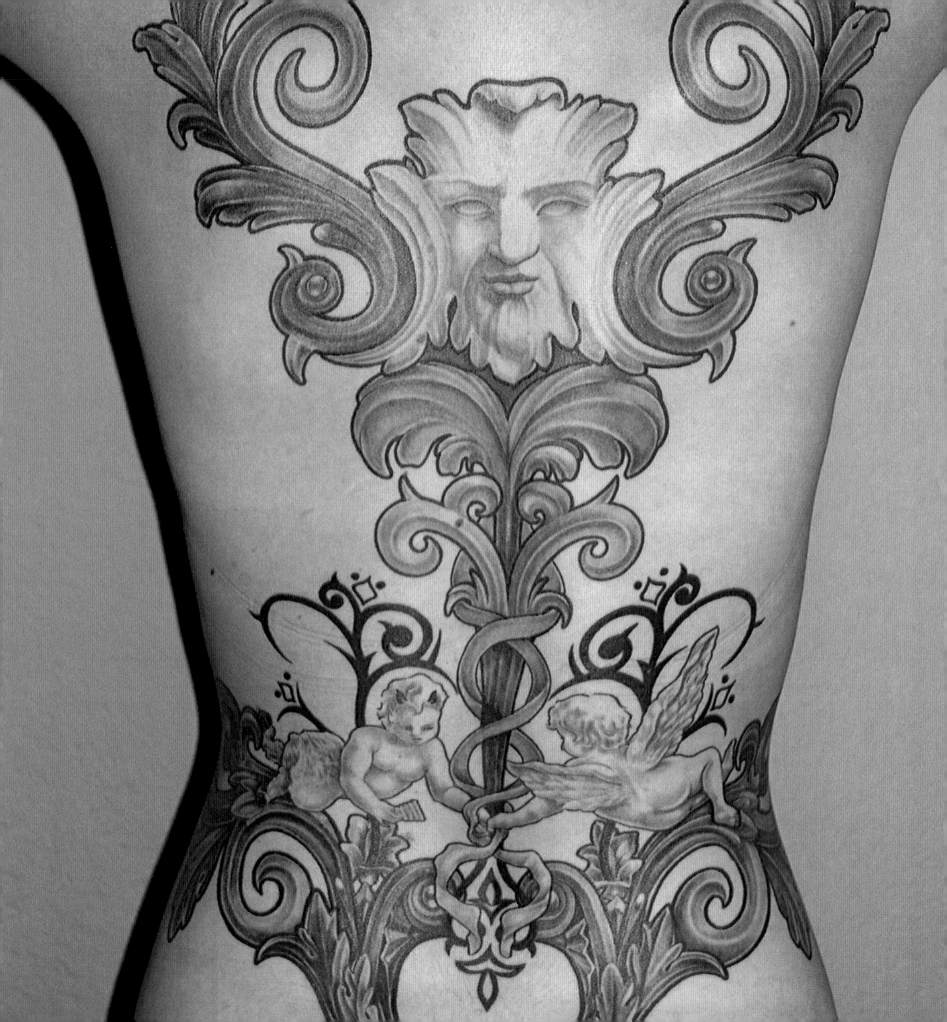

Left: Bianca by Errol Inkstitution, Rotterdam. A tattoo that mixes the ancient symbol of the green man with pre-Rapaelite cherubs. The green man symbolizes the power and wildness of nature, while in Christian iconography cherubim symbolize divine wisdom and innocence.

Right: Fozzie by Darren Stares. The very masculine tattoo style is popular, and this design is particularly well done.

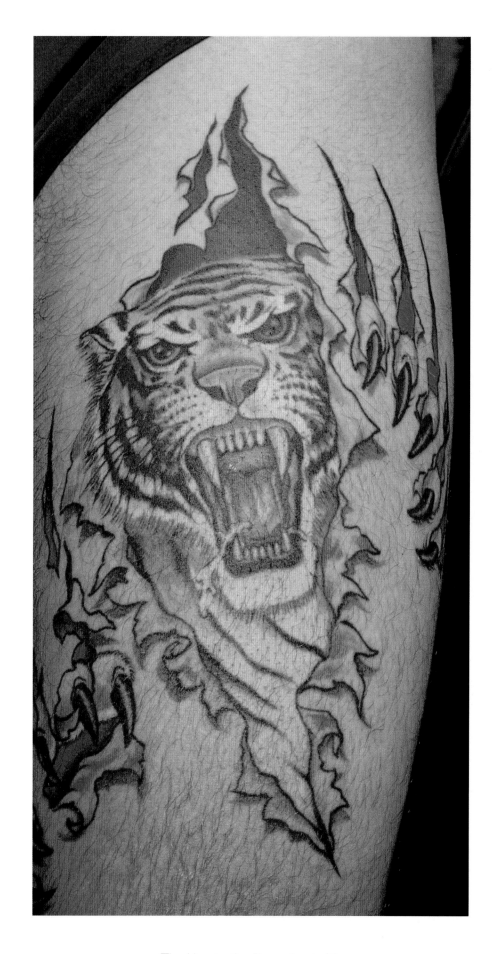

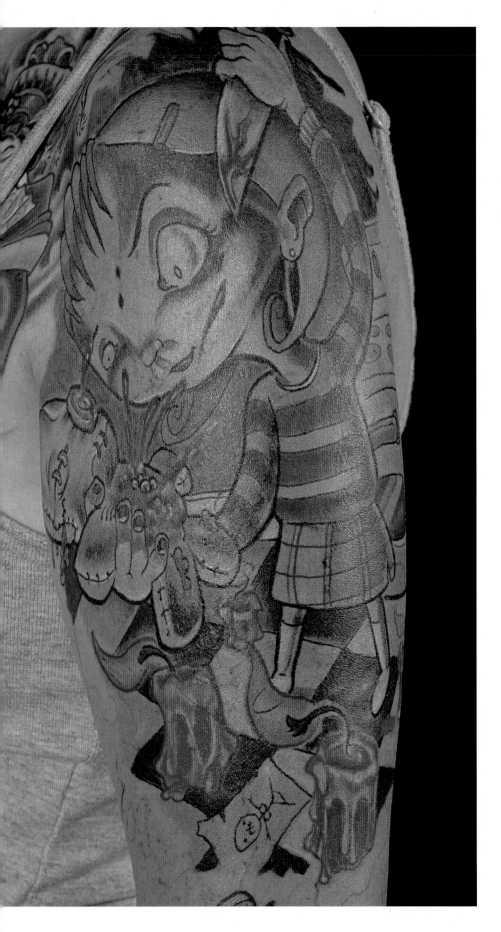

still basically the same now as when it was first produced, though it is

much improved.

Many early tattoo collectors became part of the very distinct

subculture of circus or sideshow performers. Most fabricated lurid tales

about how they acquired such body art. Typically they had been

"captured" in exotic locations and "forced" to undergo the life-threatening

art of tattooing. Performers such as Annie Howard, The Beautiful Irene,

Lady Pictura, Creola, Miss Stella, and Don Manvelo adopted exotic dress as

well as outlandish tales to attract audiences.

The tattoos were often in similar styles—scrolls of words among

decorative vignettes of hearts, animals, and flowers. This came to be known

as the "American manner" of tattooing. It was a highly stylized form and

bore messages such as "Nothing without Labor," "Never Despair," and

"Death before Dishonor." As a style it became increasingly

conventionalized and widespread and is now commonly known as the

"International Folk Style."

The fairground attraction element of tattoo subculture flourished

until World War I, when, as tattooing became more common in the

general populace, interest wore off. There were exceptions of course. In

the English circuses, a post-war figure called The Great Omi who boasted

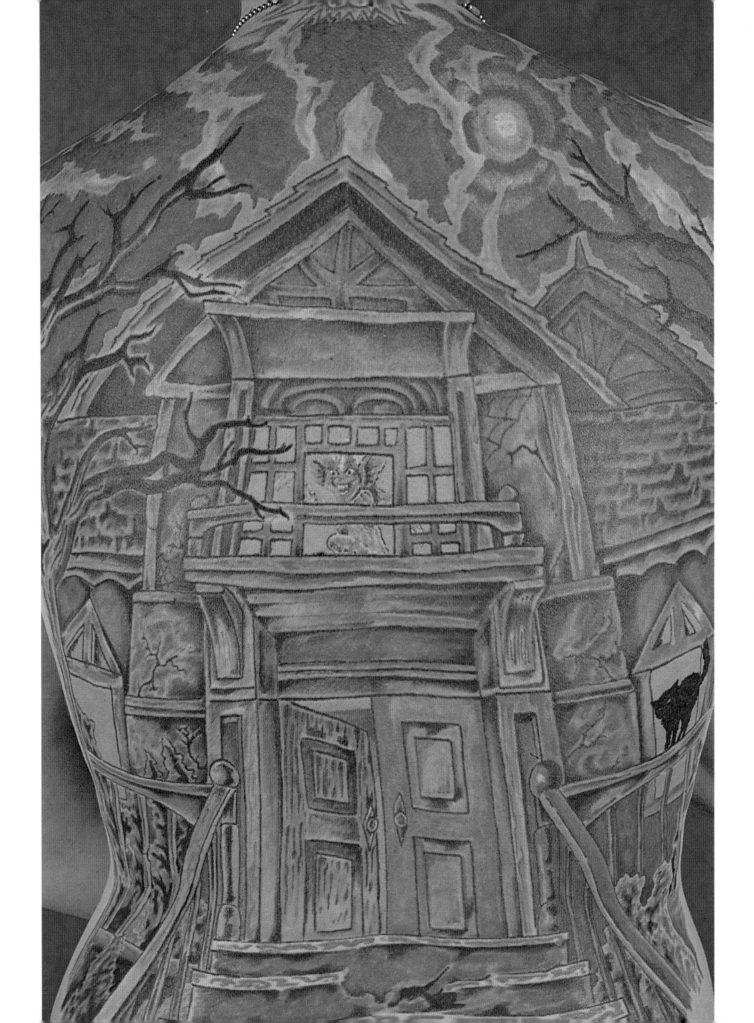

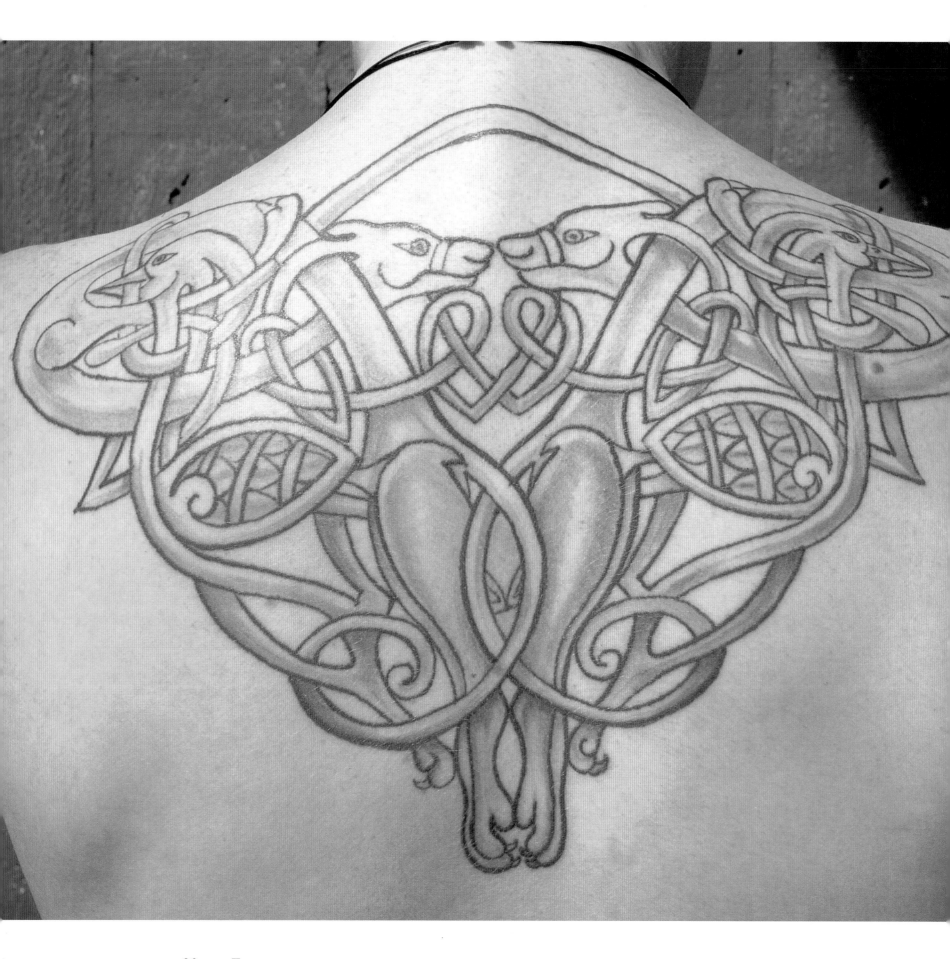

Left: Lana Raill tattooed by Bernie Shaw, Tauranga, New Zealand. This is an excellent example of tattooing derived from Celtic designs, which can be seen as the forerunner of tribal tattooing.

Above: Suzanne Beam tattooed by Chip, Gargoyle Productions, Athens, Pennsylvania. A black and gray piece in the gothic style.

zebra-striped tattooing proved a popular attraction for many years. Today, however, this tradition is almost dead, due primarily to the decline of circus in general and also the fact that extensive tattooing is no longer such a rarity. Despite this there are a number of people who have managed to carve a niche, often due to the "extreme" nature of their performances. These include the late great Michael Wilson formerly of Bradshaw's Circus of World Curiosities in Britain, The Enigma of the Jim Rose Circus, and U.S. performance artist Ron Athey.

Generally, though, much of the twentieth century was a wasteland for tattooing. Disease epidemics in the U.S., mostly around New York,

which was the spiritual home of tattooing at the time, caused a disaffection with the art and for the following decades it would be the preserve of those on the extreme fringes of society. Notable among these were bikers, who emerged in the U.S. during the early sixties, and claimed tattooing as their own. These were often extreme figures, rejecting society entirely and living wild and violent lives. Tattoos were, and are, a big part of the biker lifestyle, and along with the notion that tattooing was somehow "unclean" this stigmatized the art for many years.

It was not until the late 1980s that the art began to stir again. In an effort to kick against the materialism and the body fascism of the day, San

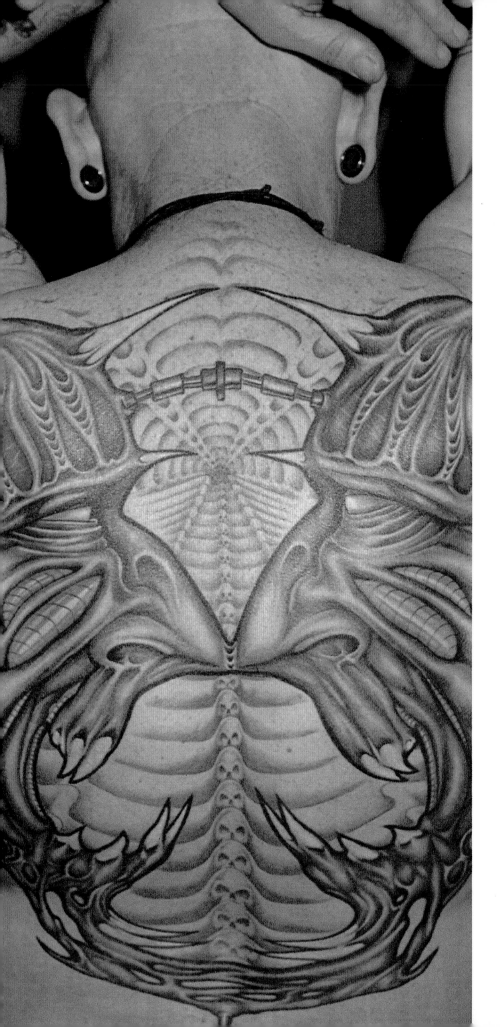

Francisco skate punks turned to more ancient, honest cultures to mark their separateness and camaraderie. The "Modern Primitive" movement was born. Now middle class, educated white kids began to cover themselves with blackwork tattooing taken from the traditions of Samoa, Borneo, Maori, and Marquessia in a battle against what they saw as a creeping standardization in culture; a quest to escape a destiny spelled out in terms of sex, age, and social origin. In this way, tattoos came to have political implications. Global products and all pervading western ideologies have shaped our view of how the world is and how it is ordered. Body art in this world view was generally consigned to a very marginal position, "something that primitive people do," the caste mark of low status or the dispossessed.

The result of this stand against standardization has been the rise of custom tattooing. Previously, tattooists had relied heavily on the use of "flash"—the sheets of pre-drawn images commonly not even designed by the artist themselves but purchased via mail order and used as stencils for their work on skin. There was now a growing demand for a more personal tattoo. Kids started designing their own pieces, then buying their own machines and tattooing each other. This saw a huge growth in the number of shops and studios across the U.S. and Europe: within a few

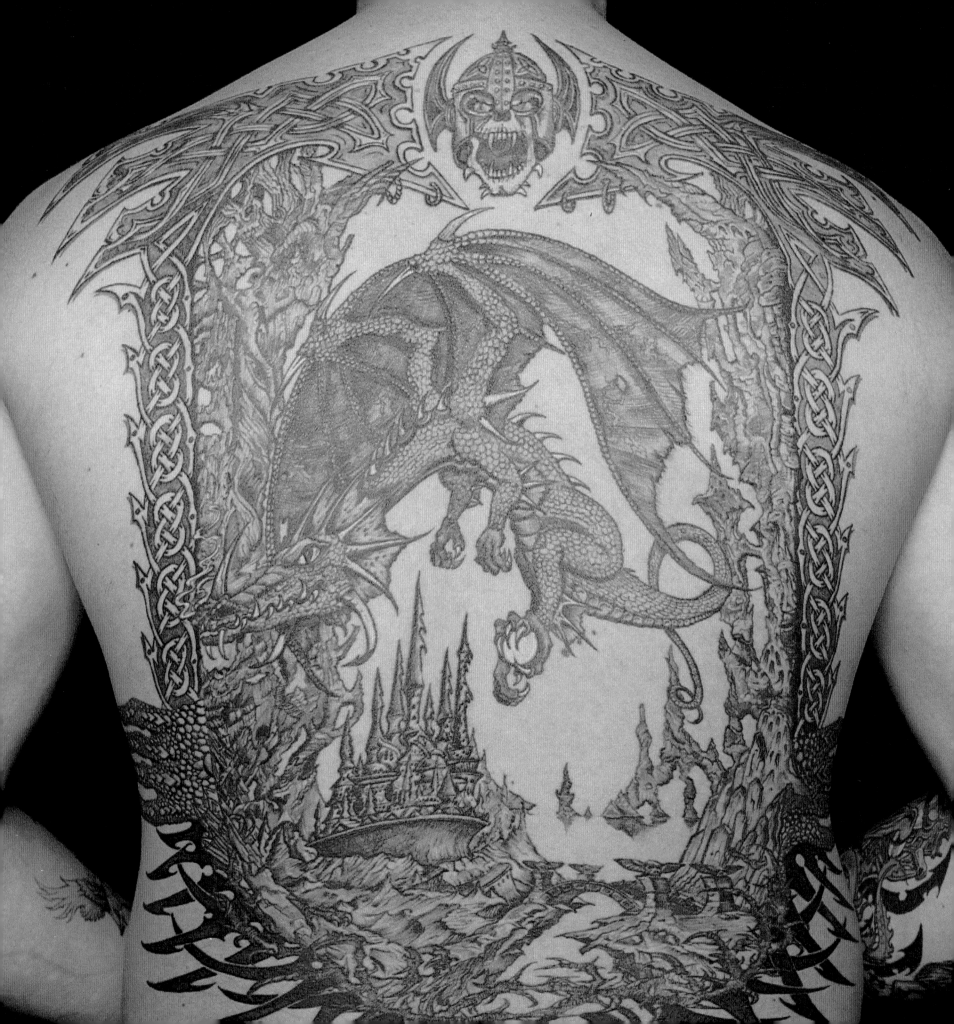

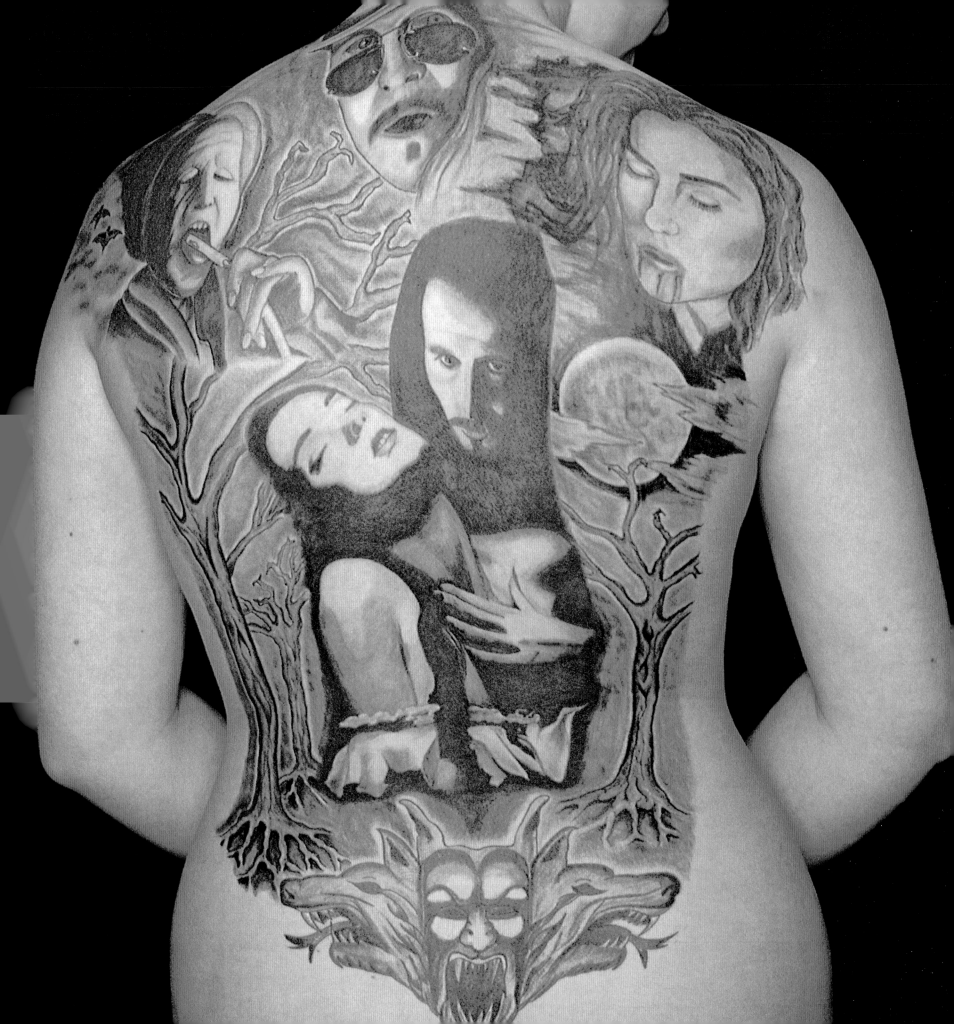

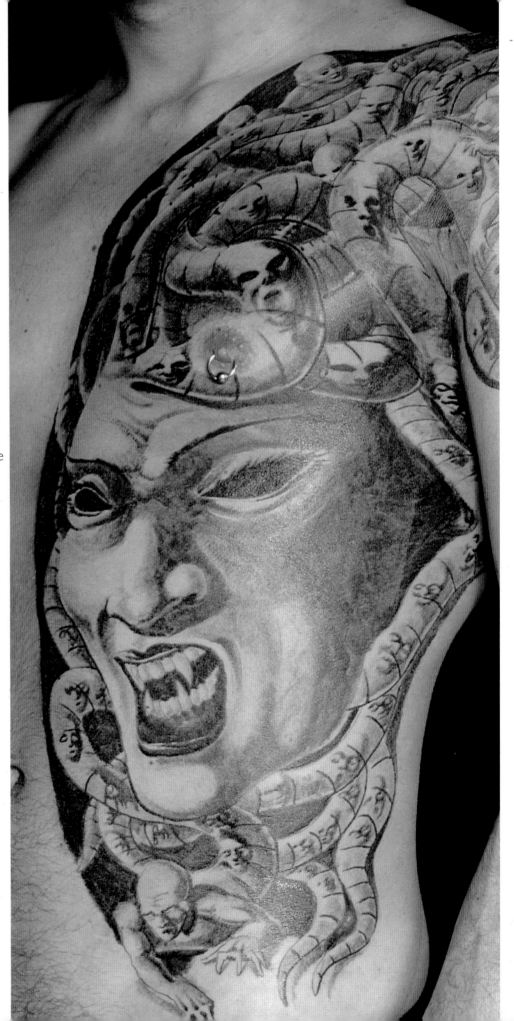

Left: Manuela by Crazy Needles, Germany. New techniques and better machinery have meant that the tattooist's palette is bigger than ever before. However, photorealistic images such as these are also the product of great talent, whatever one feels about the subject matter.

Right: Flavio by Diego Macri of Turin. Again, the subject matter would not be to everyone's taste but there is no denying the skilful and highly detailed execution of this Medusa.

short years the tattoo industry was no longer the preserve of the blue collar and the back room.

By shattering models, rejecting beauty standards circulated in the mass media, and asserting the right to do, wear, and display whatever they see fit, this avant-garde is holding up the body as one of the last bastions where individual freedom can be expressed. Throughout the 1990s the industry saw sweeping changes—new techniques pioneered by new artists, greater technical innovation, and a greater professionalism. Some see the process as a joining of the "upper and lower stratas of society... aristocrats, rock musicians, primitives, and criminals... come together in asserting their nonconformity to conventional middle class attitudes and values... a dissemination of unconventional, individualistic values, and also a reflection of better education, enhanced economic security, and openness to a wider range of experiences (including other cultures and subcultures through travel, music, dance, literature, food, dress, adornment etc.)." More simply, tattooing has become increasingly fashionable. By the turn of the new millennium what was once regarded as something of a marginalized practice had hit the mainstream. In an effort to assert their individuality and depth of

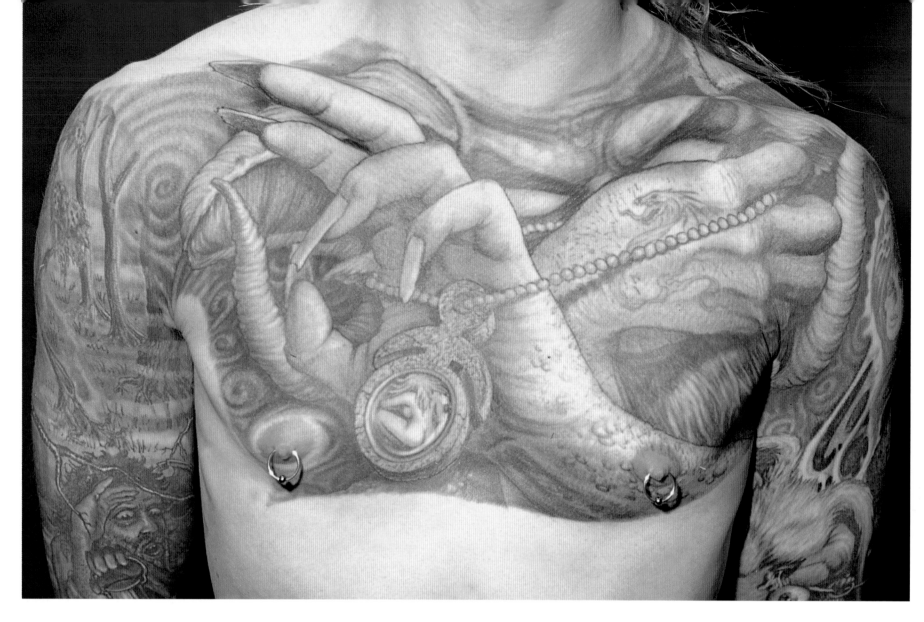

personality, public figures, actors, musicians, fashion models, and style icons adopted tattooing as badge of instant "cool." Today, more and more people from every walk of life are getting tattooed.

So where does the future of tattooing lie? Far from the ideals of the Modern Primitives we all in the West live under the shadow of global capitalism and its products. Body art has become commodified, a product, as much a fashion item as any item of clothing. In becoming so it has been divorced from its roots and connotations. In response many tattoo enthusiasts have taken the art ever further. Not since the days of the sideshows have we seen westerners exhibiting such extensive bodily coverage. Stylistically speaking we've seen a great cross-pollination of tattooing styles. The West Coast new school is blending Japanese color and themes with old school traditional simplicity. Prison and criminal fraternity lettering and imagery is being used by gang members, rap stars, and R&B artists alike. Anything is possible as new technologies and techniques are developed and more and more young tattoo artists come to the fore. We are seeing whitework applied over blackwork and more and more studios are specializing in custom work. With styles unique to the client and artist, the days of the old "walk-in" flash-style studios are numbered.

Left: Arnult by Paul Booth. This dark but stunning tattoo is an excellent example of the artist's world-renowned work.

Right: Amber Hinojosa tattooed by Jimé Litwalk, Electric Superstition, Detroit, Michigan. Amber's fascination with the Mexican Day of the Dead led her to choose that as a subject, but for her the significance lies in who made the tattoo as opposed to what it depicts.

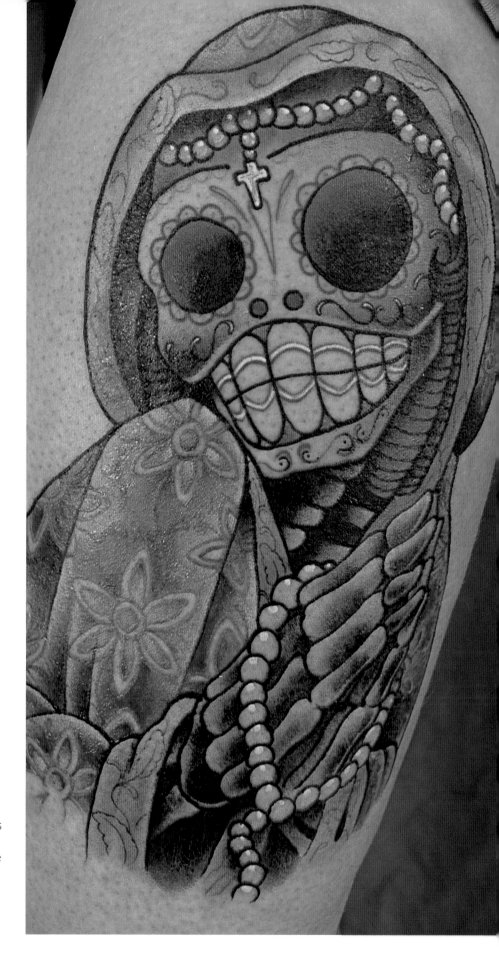

There are countless great tattooists at work today, but as in any other arena there are some real heavy hitters in the contemporary tattoo world. Known for his dark, black and gray tattoos, Paul Booth's work can also be considered "dark" on a spiritual level, espousing anti-Christian views that are reflected in some of his imagery. He started his career as a tattooist like many others; by getting tattooed himself. (Uncharacteristically sweet for a man known for tattooing demons and devils, his first tattoo was of his daughter's name.) Already being an inquisitive artist, always out to the challenge of trying something new, by the time he got his second tattoo, he was hooked. He got an apprenticeship at Ernie White's in New Jersey and

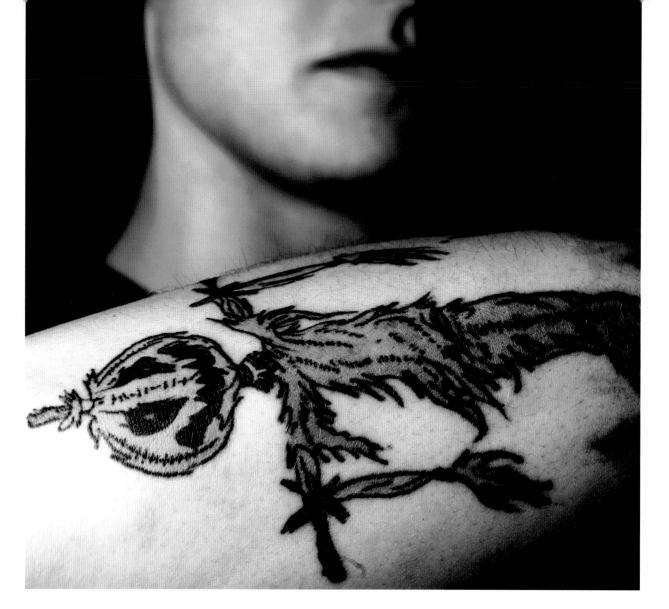

spent two and a half years learning the ropes through a steady diet of eagles, hearts, and Tasmanian devils. His own artistic vision developed slowly, in the isolation of New Jersey in the 1980s, until he saw work by artists like Guy Aitchison in magazines and realized that tattooing could be taken to another level. As he started to attend conventions and come in contact with other tattooists who were doing full-on custom work, this belief strengthened and he began developing his personal style into what it is today. Whereas he will tattoo anyone who seeks him out, (usually being given full creative reign or working off a specific theme supplied by the client), Paul saves his spiritually heavy imagery for those he feels are up to the task of wearing it; people who he feels are ready to deal with the hostility that goes along with sporting something that is considered negative by society. He weeds out those looking to become part of a trend, who would wear his anti-religious tattoos in the same way that they would wear a T-shirt.

It was his research into native American jewelry and garment design, while in art school, that led Leo Zulueta to start investigating indigenous tattooing. He realized that design motifs that recurred in various indigenous crafts formed a general aesthetic that intrigued him, and Leo soon found himself going to the library and photocopying everything

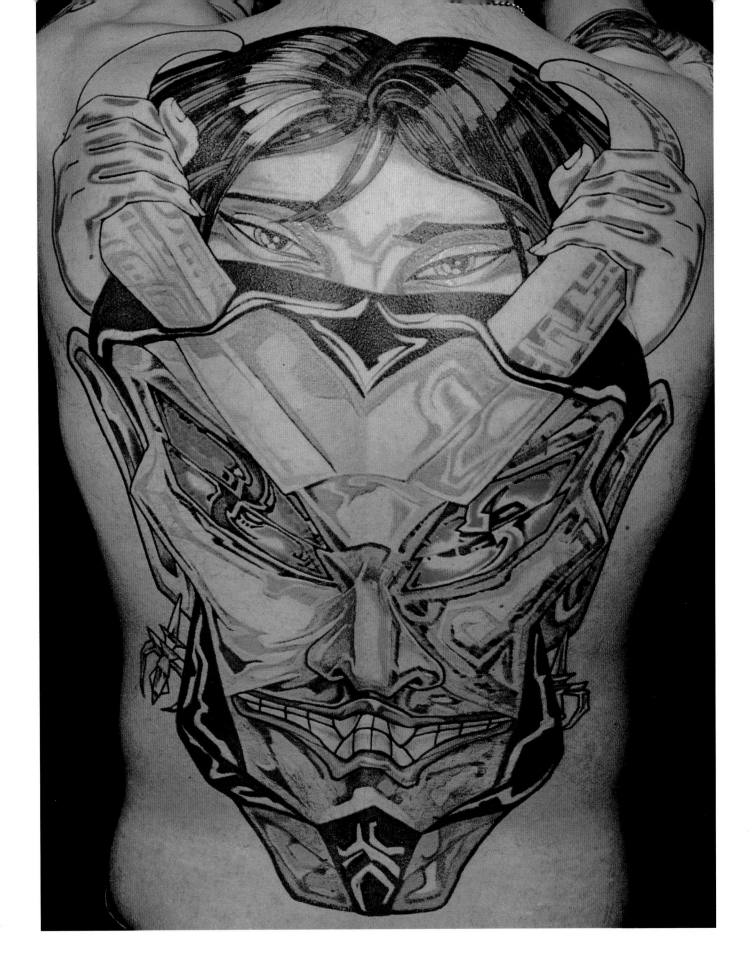

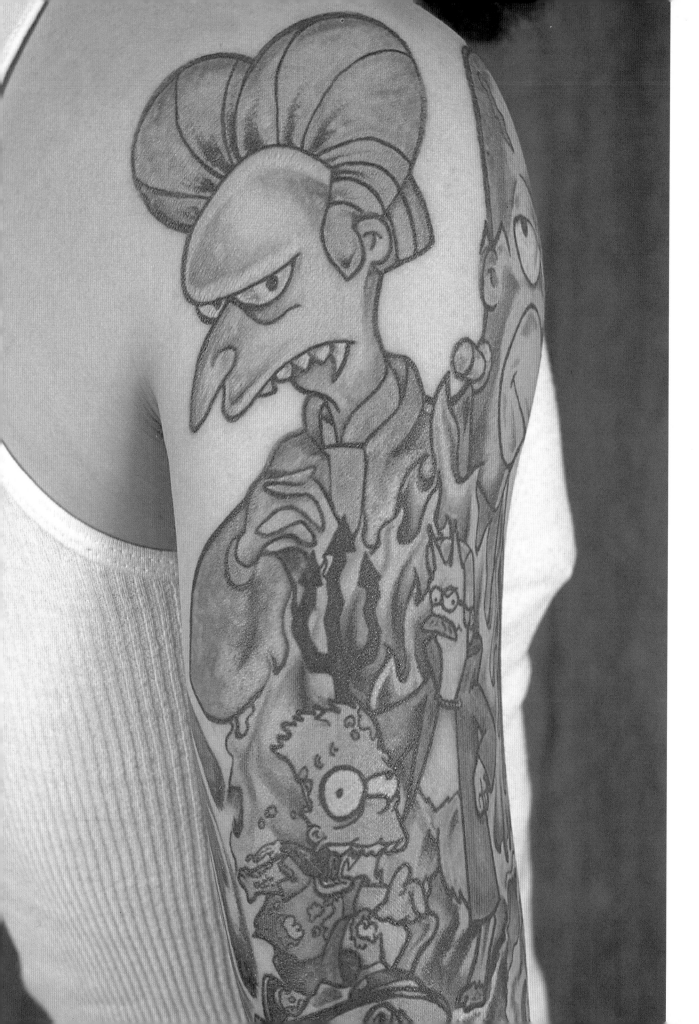

Left: Mike Kozlowski tattooed by Eamonn Carey. Among the many styles of tattooing that come and go in fashion there is always room for the less serious. This entire sleeve is based on T.V. cartoon family the Simpsons' "Treehouse of Horror" halloween specials.

Right: Steven Parker tattooed by Troll, Munkee Wrench Tattooz and Chad Lambert, Kustom Tattooz. This is another good example of incorporating imagery from popular culture (*Star Wars*) into a tattoo.

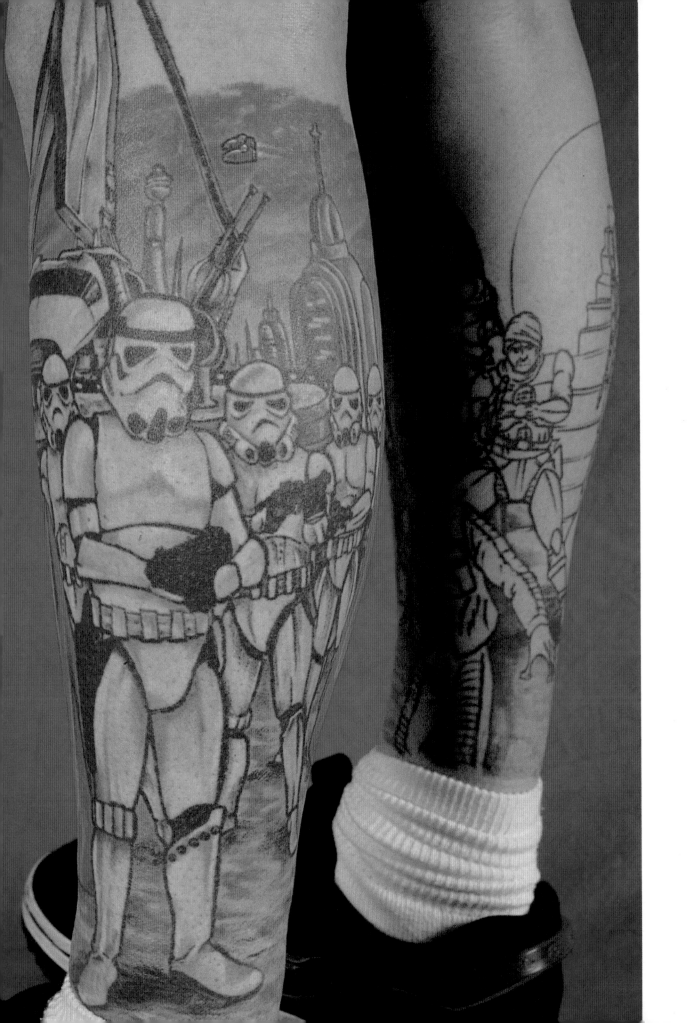

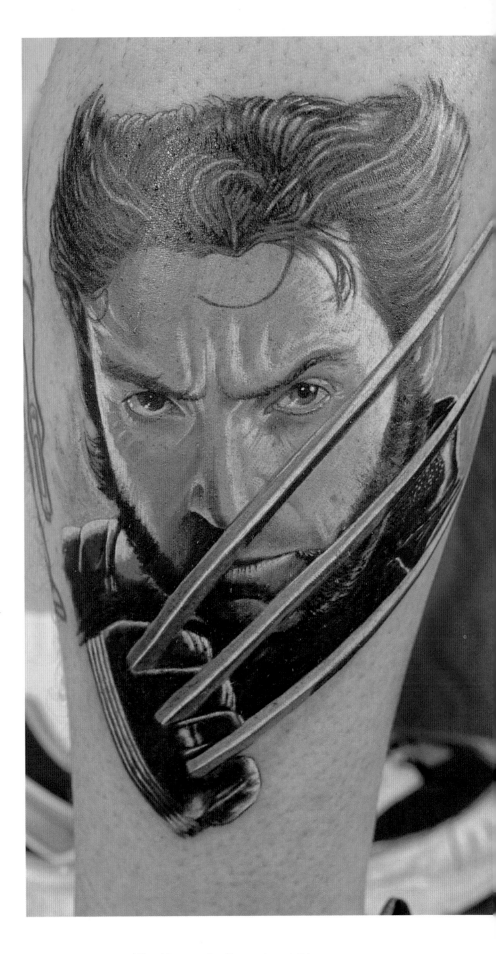

Left: Jeff Wilson tattooed by Tom Renshaw, Electric Superstition. An example of Tom's skills in the black and gray department.

Right: Benjamin T. Trayers tattooed by Jason McCarty. Another excellent example of a pop culture tattoo, this time comic book hero Wolverine.

he could on indigenous tattooing. Through his love of the tribal aesthetic, he met people who had similar interests. Don Ed Hardy, who encouraged Leo's personal research into this field, pushed him to start tattooing, believing that with his vision and passion, Leo had something important to offer the tattoo world. Leo was hesitant at first about making a career change in his late twenties, but he realized the fortunate position he was in, having Hardy as his mentor and friend, and soon he made the plunge that would lead to a long career and the creation of a new style of tattooing.

When Leo first started out, the fineline style was very popular and at the complete opposite end of the spectrum from what he was doing, so he cherished every opportunity he had to meet people with similar interests, which, in turn, encouraged him to push himself even further. Borrowing graphic elements from different indigenous styles, Leo makes a distinction between a symbol and symbolism, seeing tattooing as not necessarily being visually symbolic in a literal manner, but rather as a means to express an idea or event in one's life in a personal, perhaps abstract, way. He therefore designs each piece to fit the particulars of his client's story, making highly customized, one-of-a-kind tattoos that are deeply meaningful to the people wearing them.

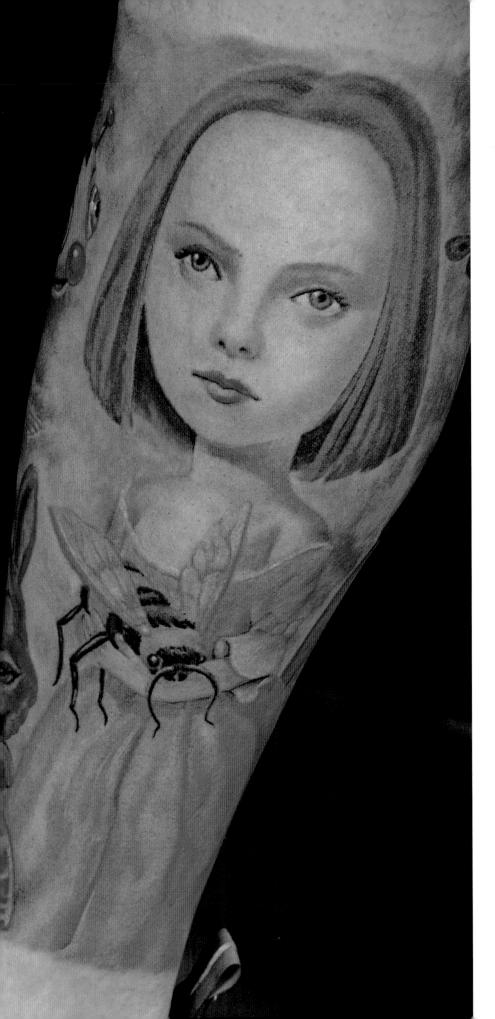

The contradictions between the history of the art form and its recent popularity are beginning to show. Some groups in society seek to appropriate the "anti-social" characteristics of body art to maintain their difference. Bikers, gangs, skinheads, and punks all use the "anti-establishment" connotations to establish their disaffiliation with the values of mainstream society. There are other groups who regard body art as just a fashion statement, but still revel in its "deviant" connotations, its potential for "shock." Others find body art to be "empowering," a "rite of passage," a return to "primitive" values. Such collectors commonly feel that elevating it to "art" status in the popular imagination will rid it

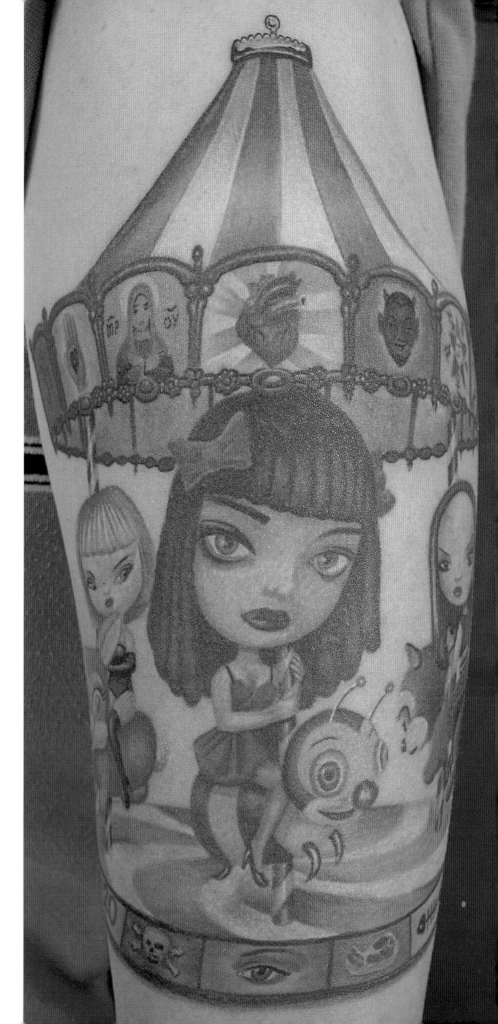

of its negative attributes. Faced with the pressure to conform, to discipline one's body in order to meet social conventions, constructing an appearance becomes a way to upset normality. Everyone becomes an actor, capable of displaying their body in a unique way. Rather than sinking into the crowd, they spark a chain of reactions (grounded or not), from attraction and fascination to rejection and fear. The refusal to comply with social norms, the awareness that looking different has an impact, is all part of a battle against the creeping standardization.

These collectors stand at opposite ends from those who undergo cosmetic surgery, drastic diets, and the like. Television and the Internet are

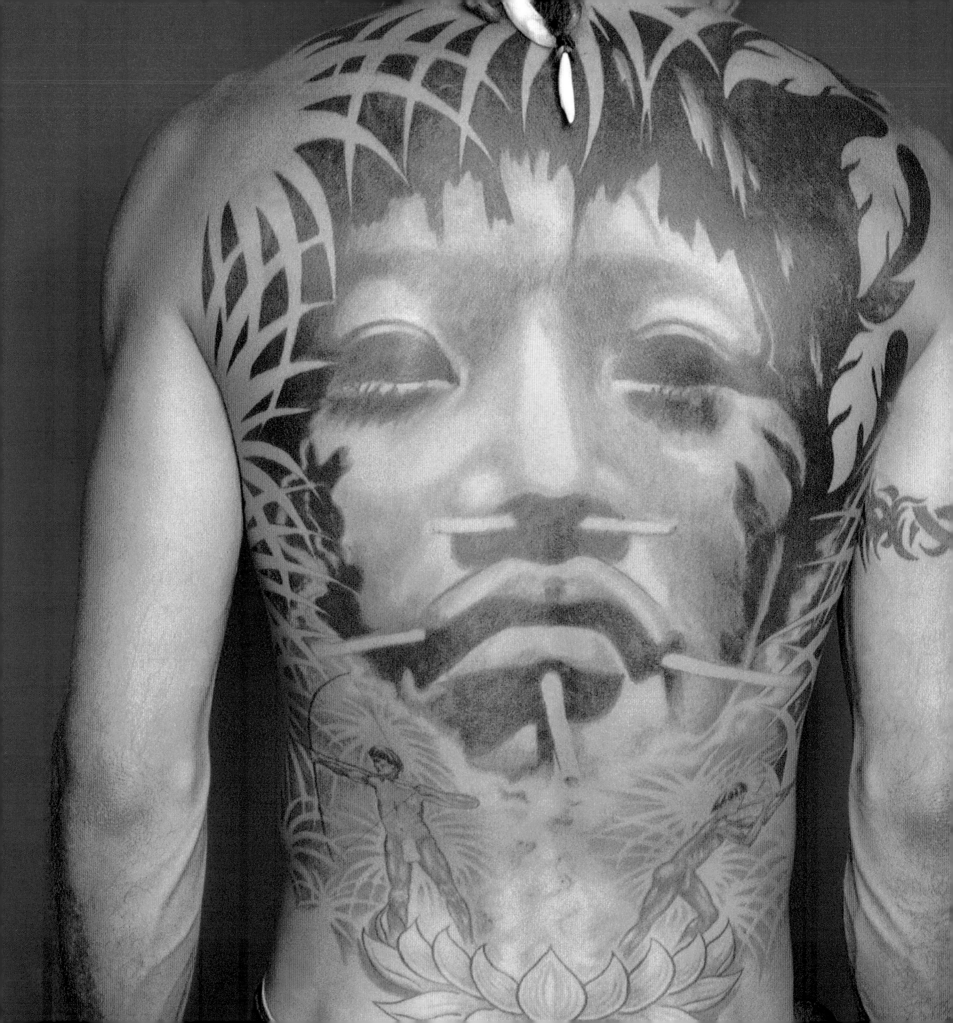

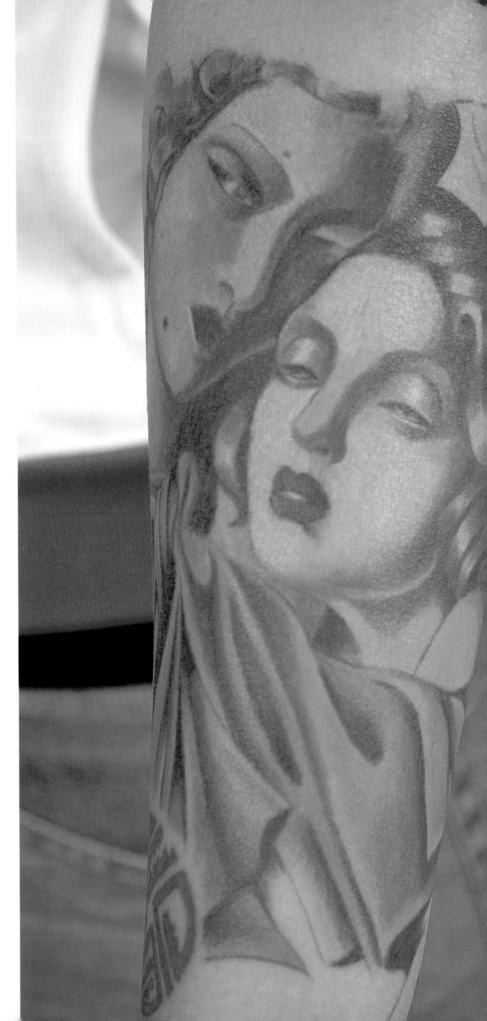

Left: Tuca by Tattoo Sauvage, France. This stunning piece of art signals a deep involvement in "primitive" values.

Right: Goska tattooed by Bugs. This example again reflects a recent trend toward tattoos that utilize styles historically reserved for fine art and are not usually found on skin. They challenge what is considered "acceptable" tattoo subject matter and style. One of the tattooists integral to this movement is Bugs, whose work is in the cubist vein.

giving play to all these trends. Day after day, we are exposed to a million ways of looking at the body, culled from past and present, from the imagination and real experiments. This should remind us that the body is not about a static anatomy, and that there is more than one way to signal membership to a group, which brings us again back round the very roots of tattoo culture.

Whatever the personal politics of the modern collector, and whatever society thinks of them, it cannot be denied that today's tattoos represent an amazing flowering of the art. And while there may be serious politics beneath the surface, not all tattoos are loaded with philosophy and deep thought. There is a playfulness in the tattoo community that is readily seen in the art. Cartoon characters are as popular as ever, though now they are likely to be more thoughtfully executed. Scenes from a favorite movie, animals, the fantastic and macabre—everything that a human can see and experience is on offer. It can be a vast piece or something tiny and beautiful that only a lover will ever see.

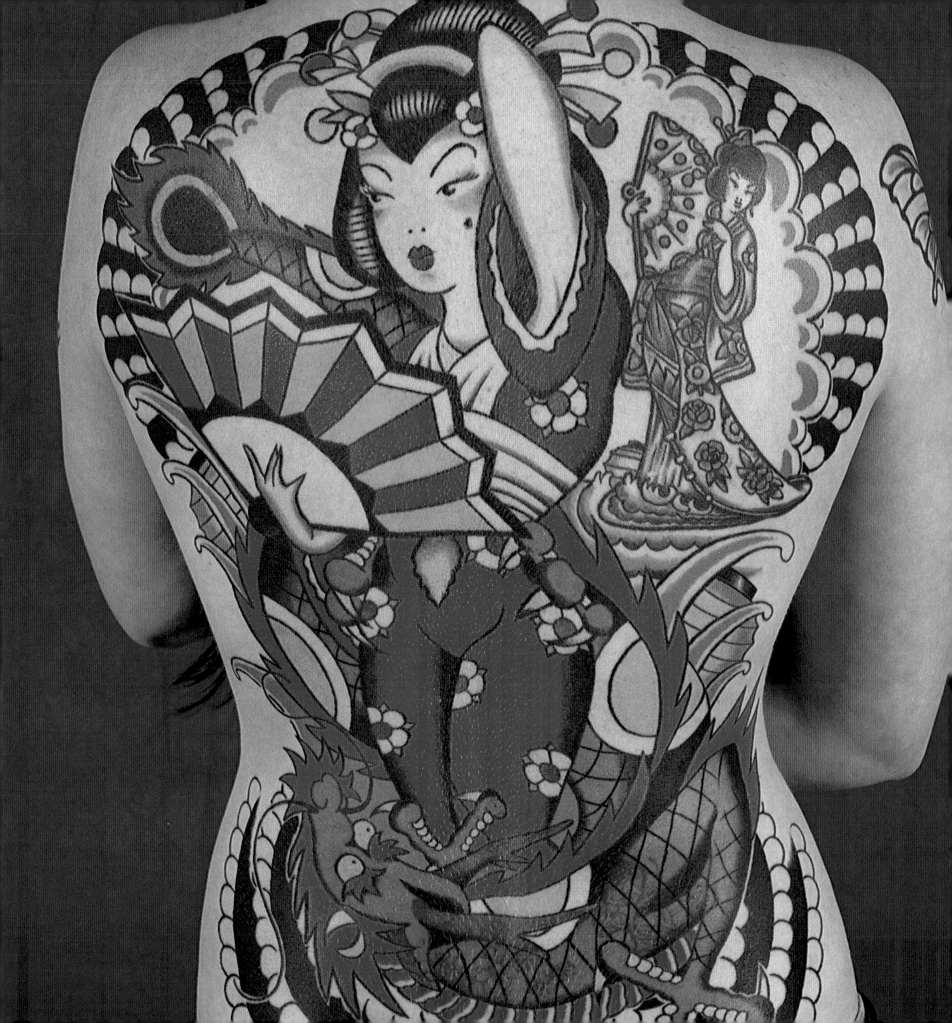

EASTERN INFLUENCES

Above: The dragon is a recurring motif in Japanese-style tattoos.

Left: Natalie Silverthorn tattooed by Luc Zietek, "What It Is," Clinton, Massachusetts. This tattoo takes Japanese themes and images and gives them a distinctly Western feel. The geisha owes as much to sailor-style tattooing as she does to traditional Japanese design.

The Japanese style of tattooing has probably had a more significant impact on our own tattooing culture than any other form or style. The image of the full body suit with its realistic detail, the skillfully executed shading and striking color, is forever locked into the Western idea of tattooing. As a result it has never really fallen in nor out of fashion. We have, it is true, seen more of a resurgence in its use over the last five or six years, but that is just part of the increased popularity of tattooing on the whole.

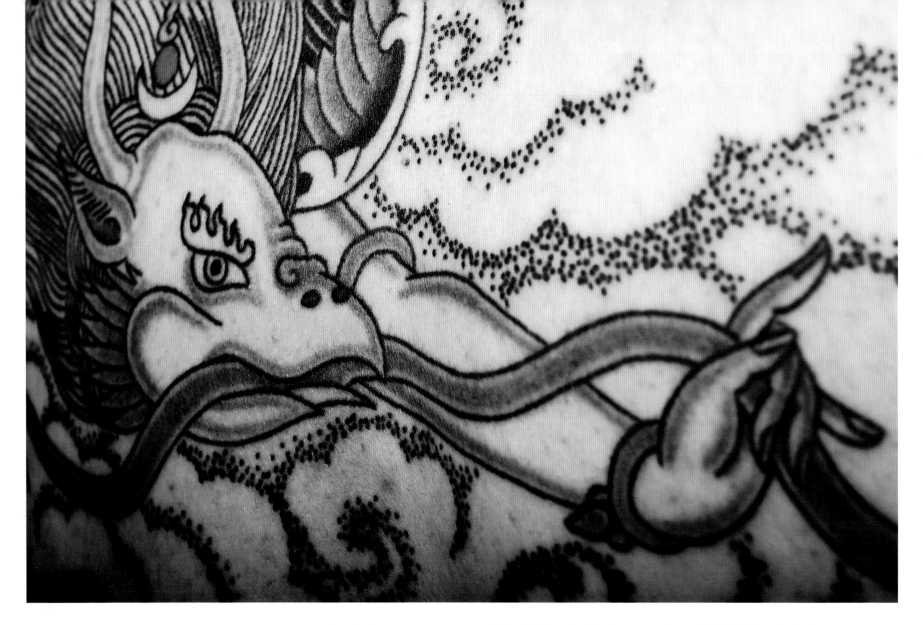

Japan's history of tattooing is extensive: the practice has been a part of their culture since at least 5,000 BC. In its earliest form, however, the designs were not what we associate with Japanese tattooing, but were more akin to those of ancient Egypt or Polynesia. Pictorial tattoos first appeared after the Horeki era (1751–1764). At this time tattoos were relatively small, and the designs were family crests or talismanic images, such as severed human heads. Even though people began to have a couple of tattoos on their body, each piece was scattered at random, not unified.

The development of the art of *ukiyo-e* fundamentally changed the style of Japanese tattooing. The *ukiyo-e* are pictures of "the floating world," mainly depicting the landscape and people's daily lives, including entertainment such as *kabuki* plays or the pleasure quarters. The images were first illustrated in color prints, but with the 1650s development of woodblock printing the *ukiyo-e* began to become widely available in books. The most significant development in Japanese tattooing came with the translation into Japanese of the Chinese legend, the *Suikoden*, the "Water Margin," by Okajima Kanzan in 1757. The heroic adventure stories of the *Suikoden* were illustrated in 1827 by Utagawa Kuniyoshi, the great *ukiyo-e* artist. Its popularity was such that it could almost be described as hysteria among townspeople. A genuine pop phenomenon with an unthought of

Left: While Japanese tattooing has distinct properties, such as shaded backgrounds, its iconography has long been purloined by flash artists to lesser or greater effect.

Right: Richard by Bob Hoyle, Halifax, U.K. Here the dragon is used in a very impressive manner, which is reminiscent old Japanese work in both subject matter and extent of coverage.

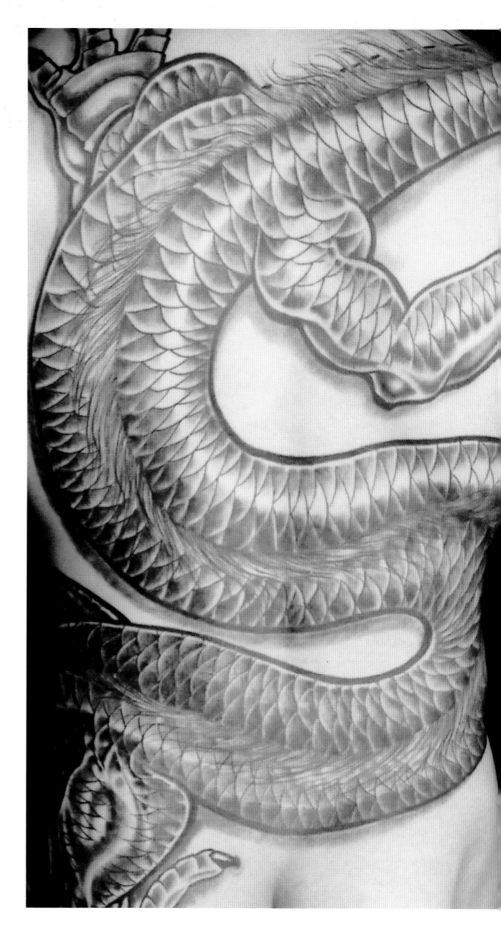

consequence—Kuniyoshi's prints inspired the development of a tattoo style that has been popular ever since. The tattooing term *wabori* meaning "Japanese style," refers to *ukiyo-e* pictures, including dragons, carp, Buddha, maple leaves, or peonies. These were the blueprints for a style that has become forever associated with Japan and many of the same images are still used today.

The idea of the full body tattoo originated with a part of the traditional samurai warrior costume called *jimbaori*—a sleeveless campaign coat. The samurai had their favorite patterns embroidered on the back of their *jimbaori* and tended to prefer heroic designs representing guardian

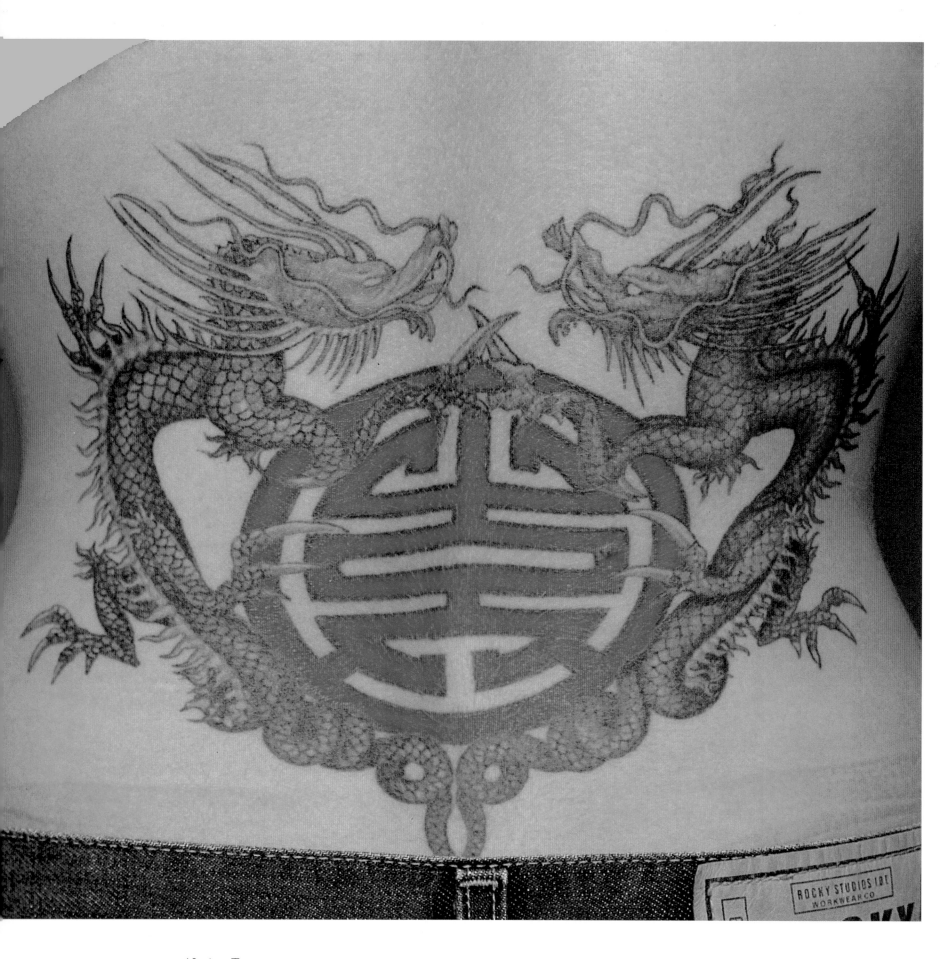

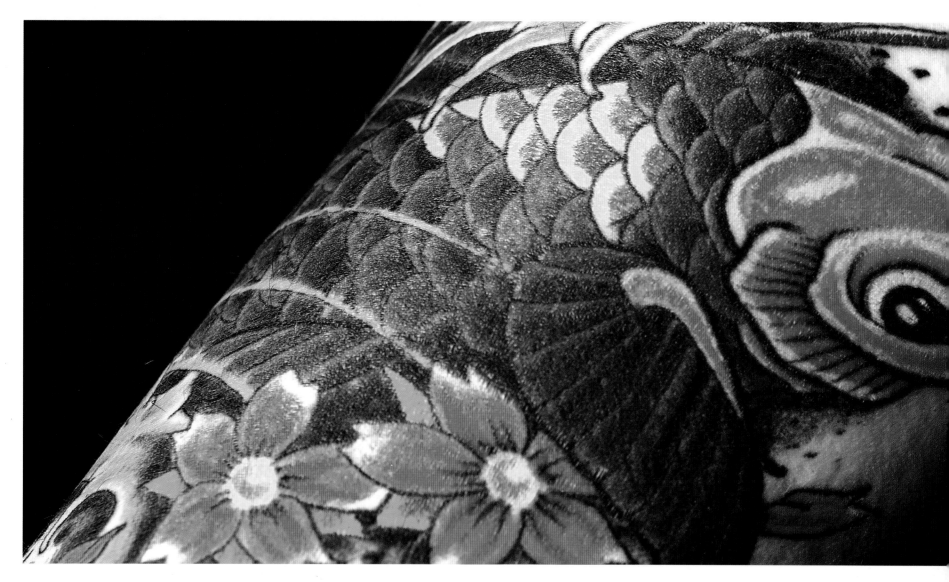

Above: A fine example of the traditional carp, which was originally inspired by *ukiyo-e* images and has remained a staple of the Japanese style ever since.

Left: Bianca by Yvonne Blut. Another example of Eastern art informing a Western tattooist.

deities, dragon, and suchlike to symbolize their own courage and pride. At first, tattooing was done only on the back, the designs extending to the shoulders, arms, and thighs. As time progressed, however, the tattooed pictures came to appear on the whole body, covering the entire front of the upper part of the torso with the exception of a vertical strip running from the chest to the abdomen, giving the effect of an unbuttoned vest. The tattoos were, of course, done by hand—the art of *tebori*. This is a special technique, and only a handful of traditional tattooists now offer it, and of these most also use tattooing machines, though in a traditional manner. It is important to note the main difference between traditional Western and

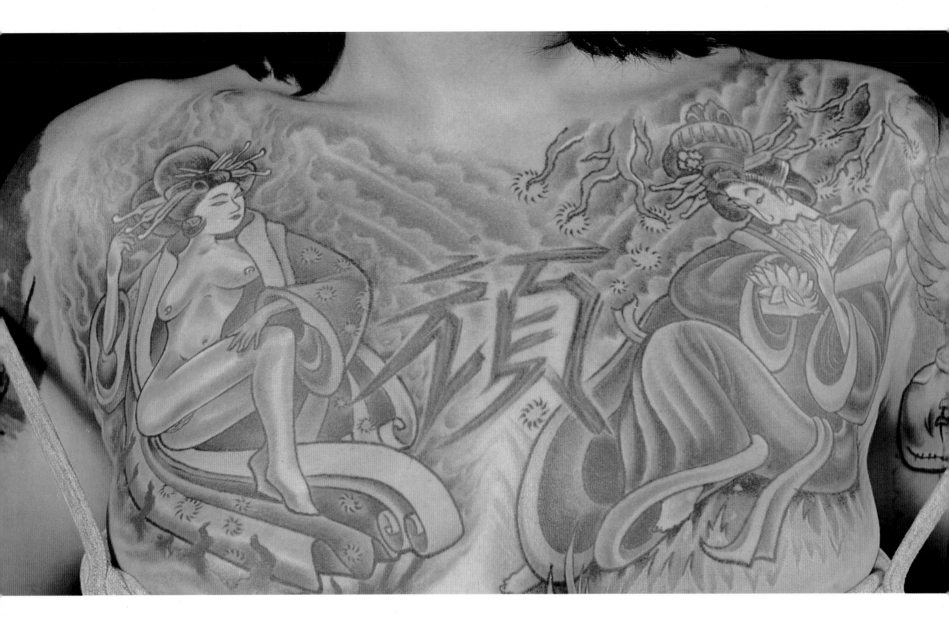

Japanese styles. In Western styles, the designs usually do not have the shaded background that are seen in tattoos influenced by the Japanese art.

The Japanese used tattooing to give personality to the naked body. A nude to them had never been considered "divine" or even beautiful as it was in the West. The sight of the naked body did not have the slightest charm. If you look at antique Japanese erotic drawings you'll notice that they never depict naked people and the women are never nude— naked parts of the body are considered sexy only in the context of their

being coquettishly revealed, glimpsed beneath the clothing. From this point of view, a tattooed man or woman could never be entirely and defenselessly nude.

The art of tattooing flowered in Japan until the mid to late nineteenth century when the Japanese government began to strive toward becoming a member of the leading industrialized nations. In order to do so it was thought that the population should appear more "civilized" and "sophisticated." The government, in an effort to modernize, prohibited all tattooing. It was deemed a "barbarous and primitive act" and in 1872 it

Left: Michelle Corwin tattooed by Durb Morrison, Stained Skin, Columbus, Ohio. Both this tattoo and the one to the right are good examples of how Japanese themes and techniques have been appropriated by the West. The colors are strong and the shading extensive. Of course, the influence can also be seen in tattoos that do not have such an obvious Eastern heritage.

Right: Christy LoPresti tattooed by Jim LoPresti, Lucky Soul Tattoo, Ansonia, Connecticut & Zee (tribal on lower back). This backpiece is of Kwan Yin, the goddess of mercy, compassion, and forgiveness. The faces on the backs of her arms are Bernini sculptures called "The Blessed and Damned Souls" representing the good and evil present in all of us.

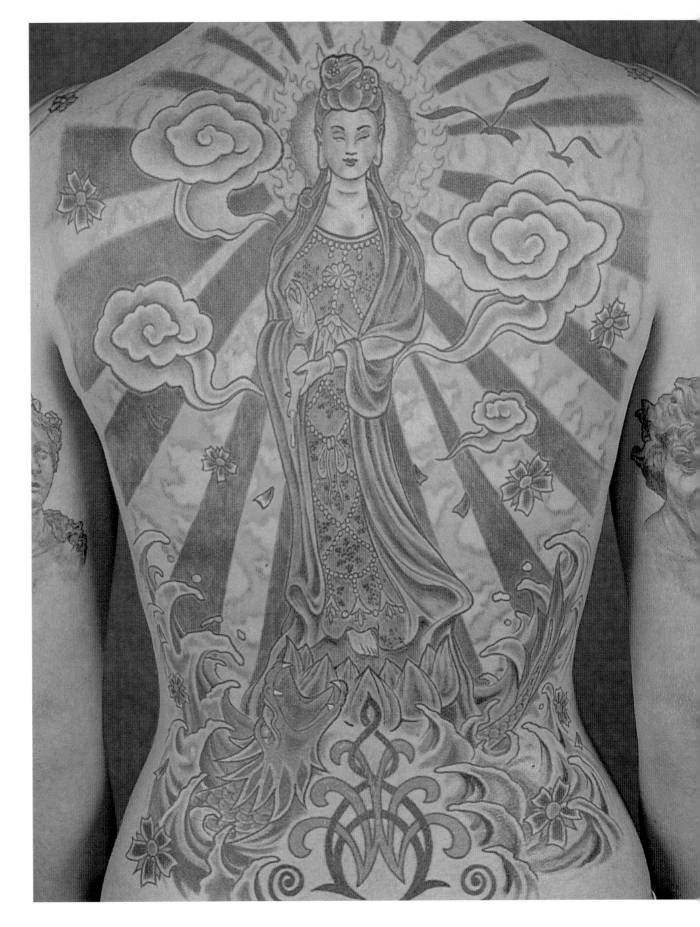

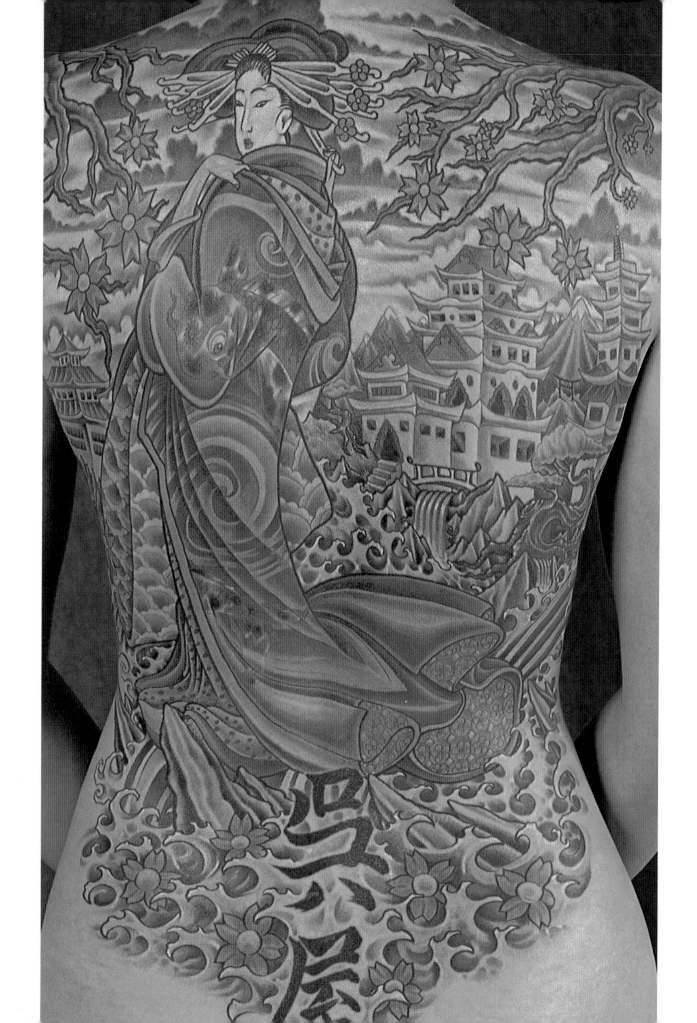

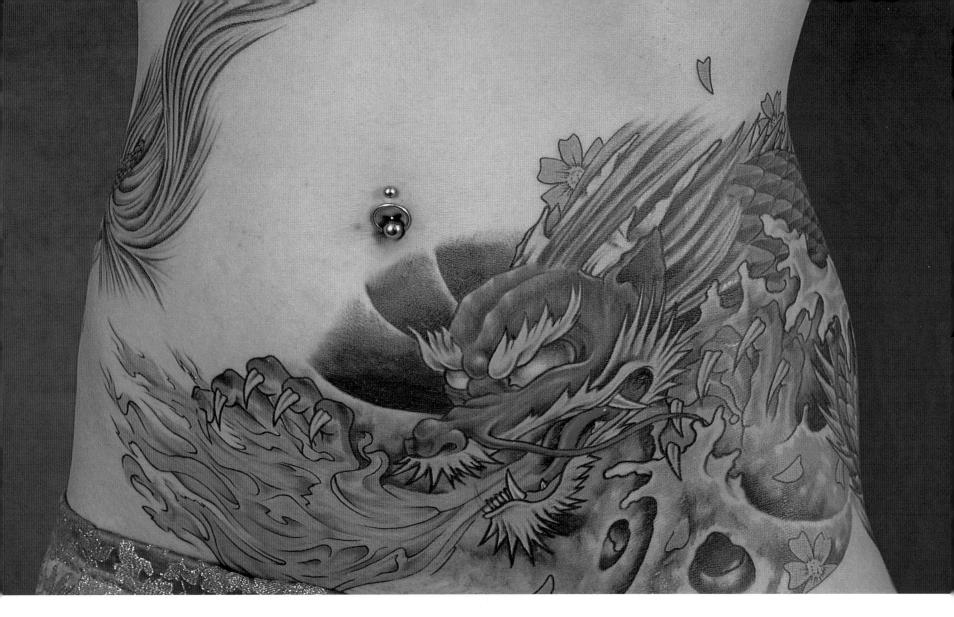

Above and Left: Although these designs are by
Western tattooists, they are much more
traditionally Japanese in feel.

was banned. Thus, during the first half of the twentieth century, tattooing

remained a forbidden art form. In 1948, however, the prohibition was

officially lifted. One of the principle reasons for the change in law was the

huge demand from soldiers of the occupying American forces for

Japanese-style tattoos. Now legal, the art blossomed once more. As a

direct result Japanese tattoos were exported to America and across the

world, acquiring an international reputation for great beauty.

Although their style of work is highly regarded in the West, the

Japanese themselves now generally have a somewhat different attitude.

Since the advent of Confucianism and Buddhism, and partly due to the

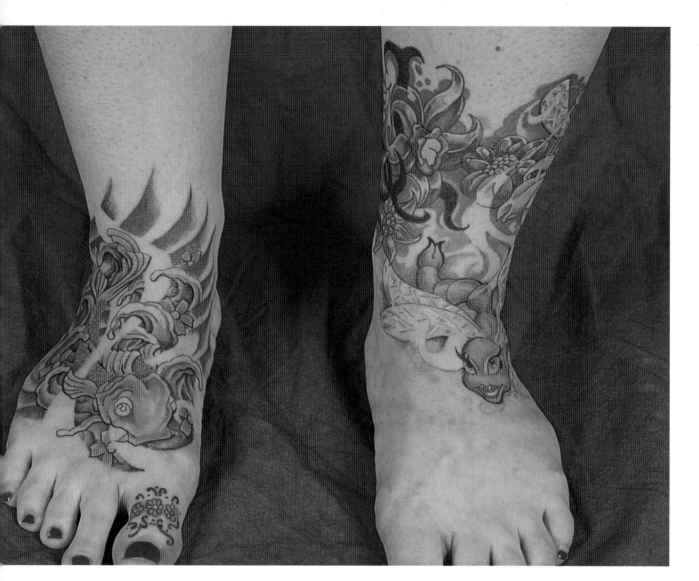

long prohibition, tattoo art has become anathema to the majority of the Japanese people. In the eyes of an average Japanese, a tattoo is a mark of a *yakuza* (a member of the Japanese mafia), a macho symbol for members of the lower classes, or the sign of a prostitute. The *yakuza* are notorious Japanese syndicate members and tattooing is their most famous trademark. However, in recent years, it has been reported that the number of *yakuza* with tattoos has been decreasing. The younger members are forsaking the full-body pictorial tattoos, opting instead for a simple line drawing or phrase on their upper arm, similar to the tattoos of Western youths. The reasons are simple; increased law enforcement has meant that their income

has been eroded and extensive tattooing is time consuming and painful. The traditional Japanese tattoo takes a long time to complete—to wear the full body tattoo, one needs patience to endure the time and pain. They also cost a fortune, and so are increasingly seen as being not worth either the physical or financial stress.

In an extraordinary exchange of styles, contemporary tattoos in Japan are typically in the Western style. While traditional designs are decreasing in popularity, "one-point tattooing" is gaining ground among young people. "One-point" means getting only one tattoo, and is trendy among young Japanese, who now often choose to wear skulls, roses, or

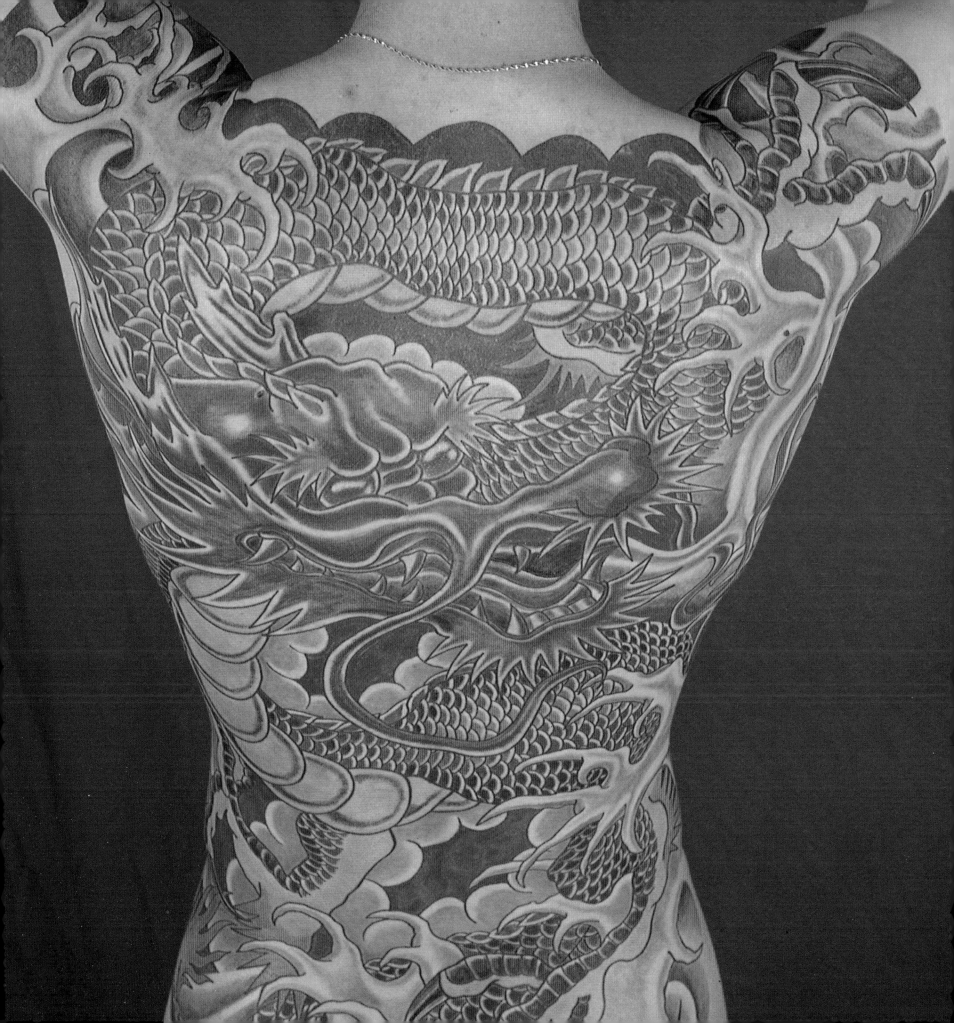

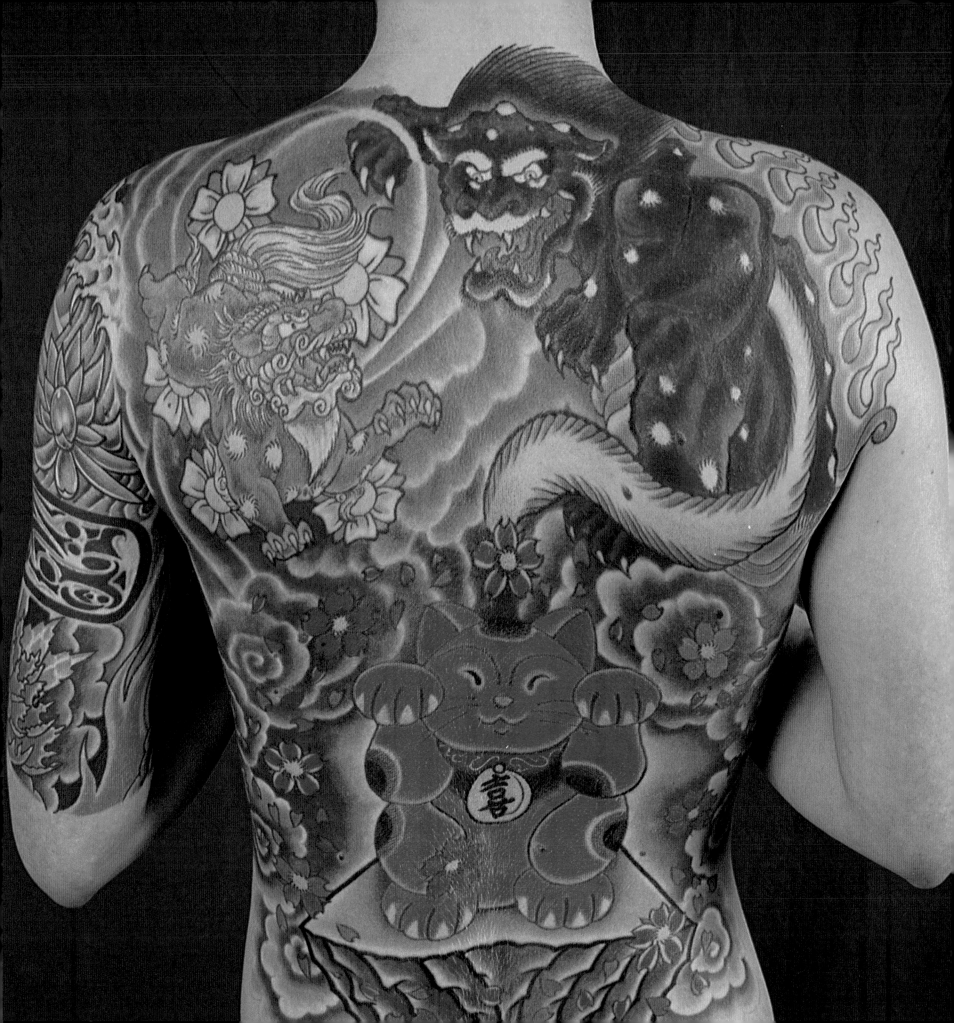

Left: Rebecca Russell tattooed by Mark Vigil, 4 Star Tattoo, Santa Fe, New Mexico. Rebecca utilized the Chinese "good luck" cat to symbolize health and prosperity, colored it pink to represent love, and included two Japanese foo dogs as guards.

Right: Jill Guarino tattooed by Litos. An excellent example of cultural mixing, here the Japanese style is used to illustrate Ganesh, the Hindu elephant-headed god who removes obstacles.

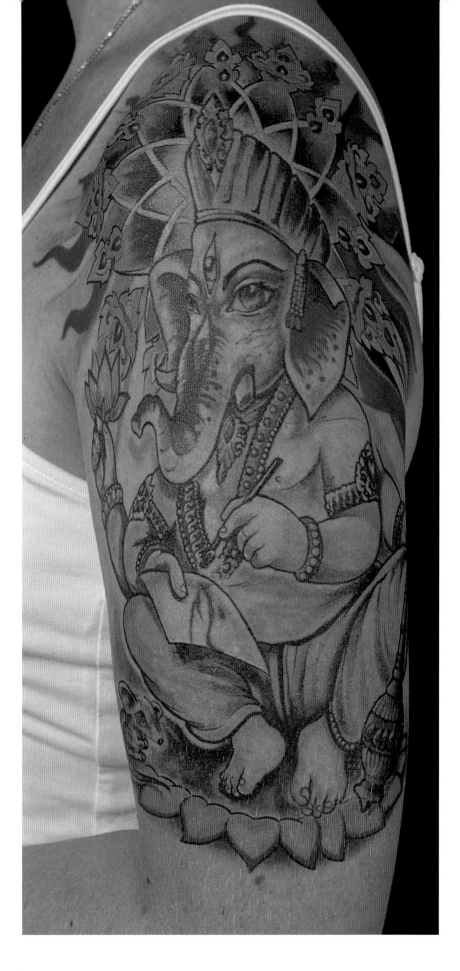

hearts. The cultural code is still a big part of Japanese society, but attitudes toward the one-point tattoo and the full body tattoo are much different. The one-point, having fewer connotations and involving much less coverage is gaining acceptability as a fashion trend among the young. It's also worth noting that the sales of temporary tattoos have skyrocketed—their impermanence means that young people can enjoy tattoos without any risk of breaking cultural code.

There is another twist—tattooing has become more popular among Japanese females than males. Where it was once dominated by males, the tattooed female population is increasing at a faster rate. The obvious reason for this is the prevalence of the fashion industry in Japan. As more and more models, singers, and other stars become tattooed so it is becoming increasingly established among Japanese women.

There cannot be many instances of such an artistic swap in history; the East now covets the traditions of the West, while the West bases its own designs on those of the East. In this strange tangle of appreciation, the West has seemed to benefit the most. Tattoo designs imported from such a disciplined society bring an unrivaled level of artistry. Quite simply, Japan's inspiring images should forever be taken as a benchmark of quality.

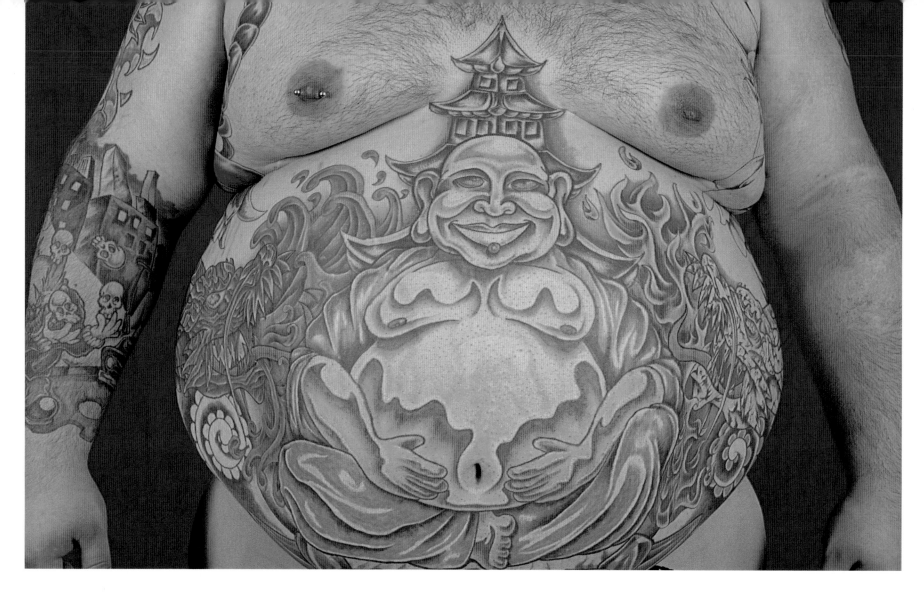

Above: Jeremy Renfro tattooed by Penny Schuhrke, China Doll, Hammond, Indiana. Jeremy's Buddha belly is probably the best example we've seen of working a tattoo into one's own body lines and shape.

Right: Bordering on the fantasy genre, this epic tattoo has the characteristic, winding, serpent-like body of a typical Eastern dragon figure.

Of course, though Western design is heavily influenced by the Japanese, the actual art is just as likely to be influenced by other Asian cultures. Recent times have seen many more people traveling to different parts of Asia as well as embracing the philosophies of Buddhism and practicing yoga and mediation. The fascination with these rich and colorful societies has introduced many different themes and perspectives to the Japanese palette. In overlapping Tibetan and Indian cultures, among others, with Japanese design, Western tattoo artists are creating a new style of tattooing of their own.

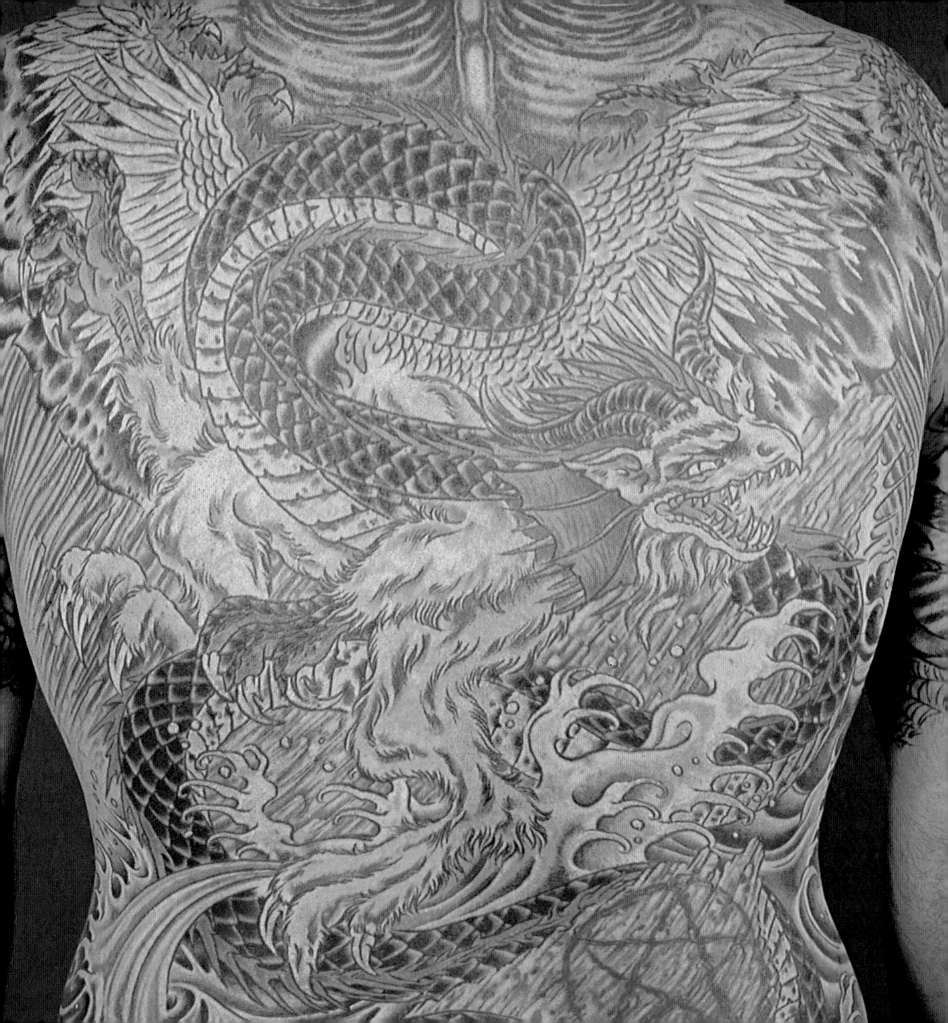

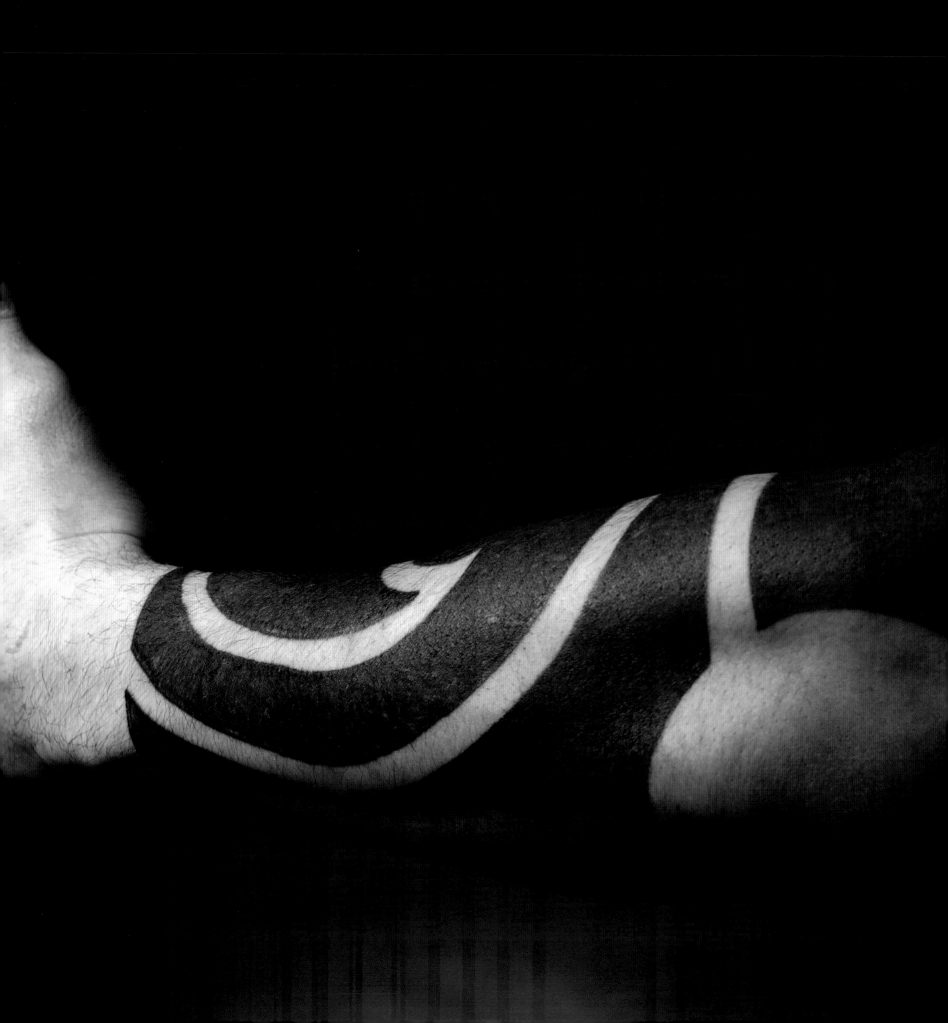

BLACKWORK

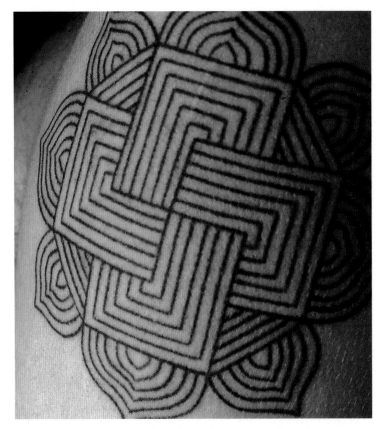

Above: A complex geometric knot design, inked solely in black. Such designs are very common today.

Left: The strong swirling lines of tribal tattooing adapt to the body in a striking fashion.

The terms "blackwork" and "tribal" tattooing are often taken to mean the same thing, and indeed tribal tattoos are so popular today that they form the majority of all blackwork. However, it is worth differentiating the two terms. Blackwork is a tattoo made using only, or primarily, black ink whereas tribal-style tattoos (which can be any number of established forms) are derived from designs originally worn by indigenous peoples for religious reasons, tribal identification, or folk superstition. What all these styles have in common is that they are primarily monochrome, being black and skin tone in nature.

The scene for the phenomenon of black only tattoos was set by "Celtic" blackwork, which was popular across Britain and Scandinavia during the mid to late 80s. Though often intricately and beautifully designed, Celtic tattoos were adapted from other forms of art and not from a tattoo heritage, so cannot strictly speaking be regarded as a part of the tribal movement. Instead, they can be seen almost as a statement of intent for the intelligent option and a spark for the huge explosion in black tattooing that was to follow.

Although the Celtic style never really caught on in the U.S., this work had become the tattoo of choice for Goths, nouveau-hippies, and heavy metal fans alike. The same people, in fact, who were the first across Europe to embrace the subsequent tribal style.

As mentioned in the first chapter, the earliest exponents of the tribal style were members of a particular subculture in San Francisco, who were looking for a stronger, more committed way of asserting their individuality and their rejection of the consumerist ideals that had developed during the previous decade. At the same time there was a growing awareness of ecological issues and a corresponding interest in "new age" ideas of living in harmony with the environment, as well as with older cultures and ancient civilizations that had seemed to achieve this. Inspired by the traditional

Above Left: Nadine Diaz tattooed by Orlando, Belladonna, Austin, Texas. This kind of work is often referred to as "tribal" tattooing. A more accurate description for this style is "blackwork," since it has no direct connection to any particular tribe or tribal peoples.

Above: Despite having no tribal connections, designs such as this are both striking and appealing. Though somewhat eclipsed by New School tattooing, blackwork continues to make up a large proportion of all new tattoos commissioned.

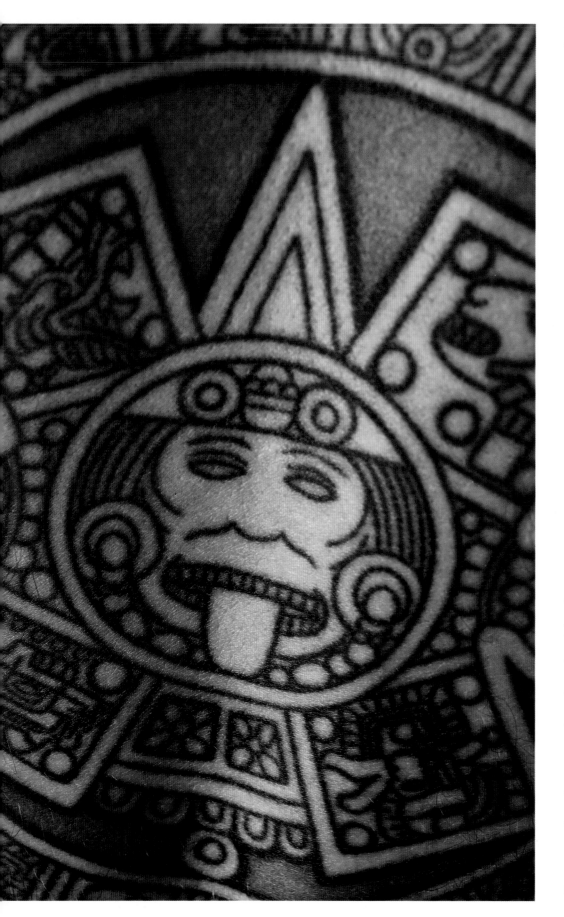

designs of the people of Samoa, Borneo, Marquesa, and New Zealand, artists like Leo Zulueta (who is credited with starting the modern Western tribal tattoo movement) began looking at the roots of the patterns, ultimately producing a contemporary form of work that took traditional designs and reworked them in highly personal ways for a modern clientele. The tribal style of tattooing was born. Its bold, swirling, black designs adapt onto the body well, and maintain a crisp appearance over time.

"Tatu" in Samoan means "to strike" and their traditional patterns are literally hammered into the skin. Areas of solid

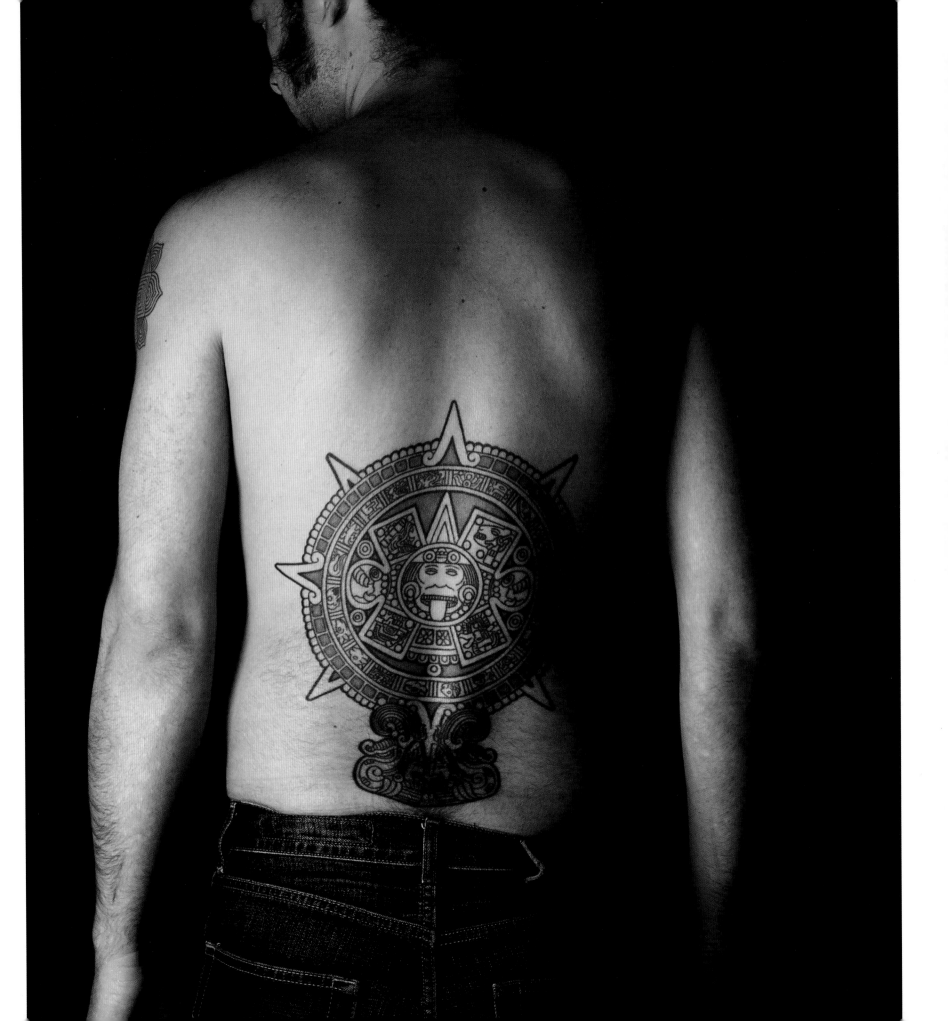

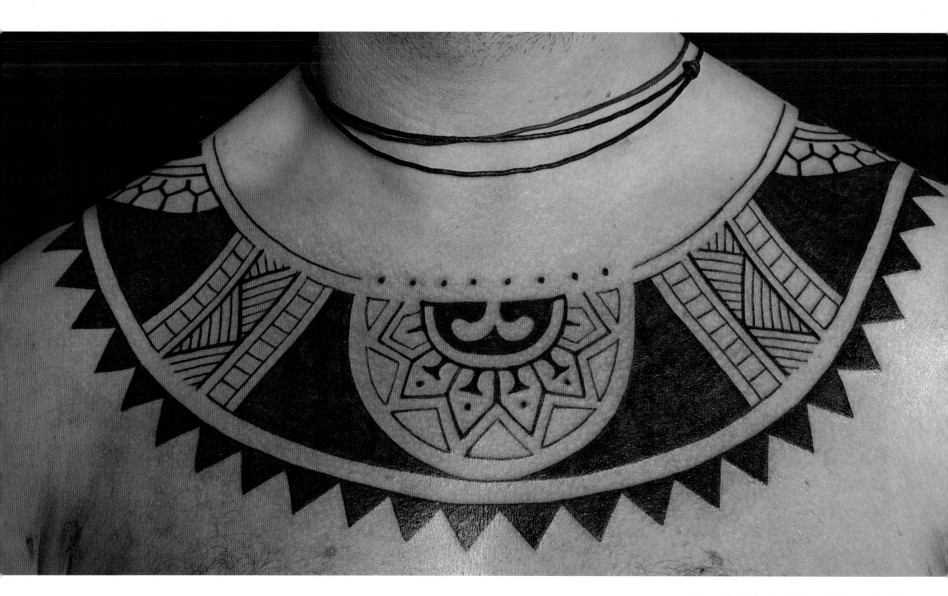

black intermix with delicate geometric designs across the lower abdomen and continue down the thighs to create the characteristic "britches" look. These patterns were, and sometimes still are, tattooed with a pair of wood-handled tools: a toothed "rake" and a slim stick that is used to strike the handle of the rake so that it punctures the skin. In fact, there is a traditional story that narrates the origins of these instruments. It says that tattoo designs were only painted upon the skin until a Samoan adventurer traveled to the kingdom of the spirits. He was treated very well by the inhabitants, but they found his painted body decorations a pale imitation of their own tattoos. He was taught the art of tattooing, and when he

Above: Carlo by Oogie Boogie. A stunning Mayan inspired collar that unusually uses red as a background color, giving the piece a little more depth and texture.

Right: Andre Munro tattooed by Nehe Ruben. This is a modern traditional Maori tattoo done by Nehe, who is part of the recent resurgence of Maori tattooing and traditional arts in New Zealand.

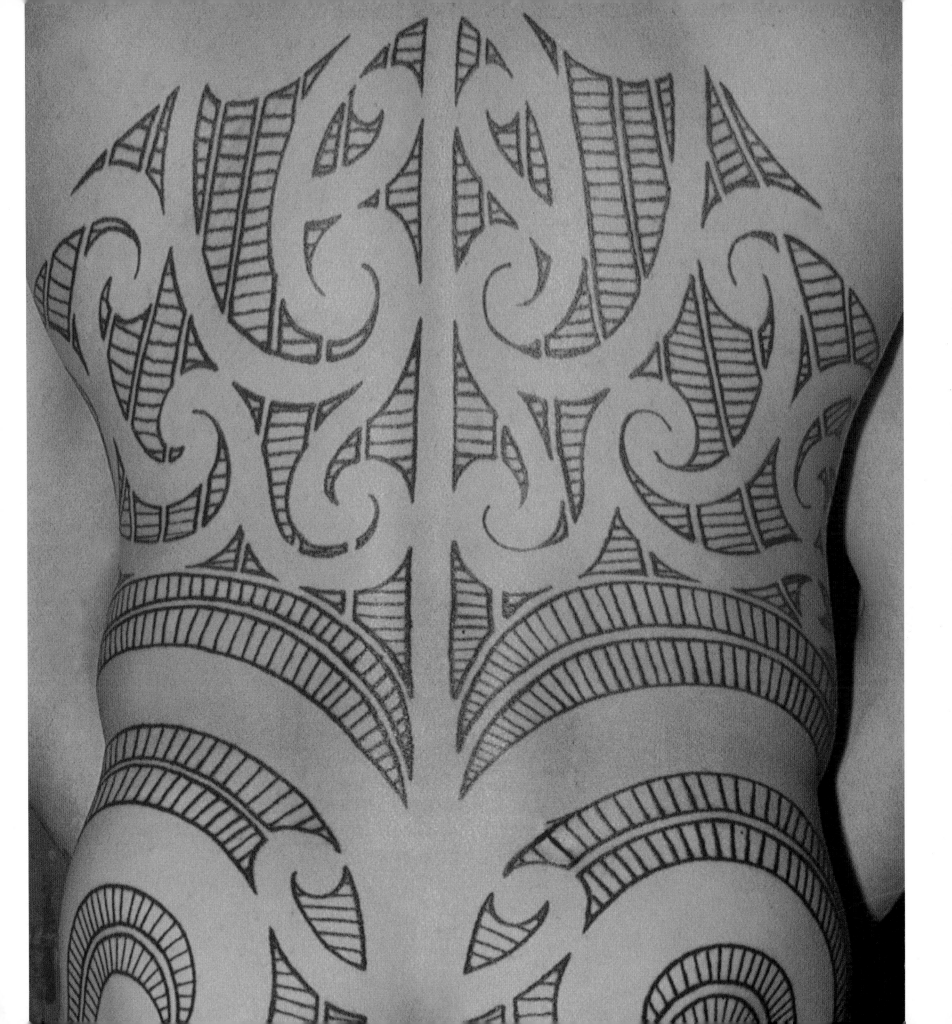

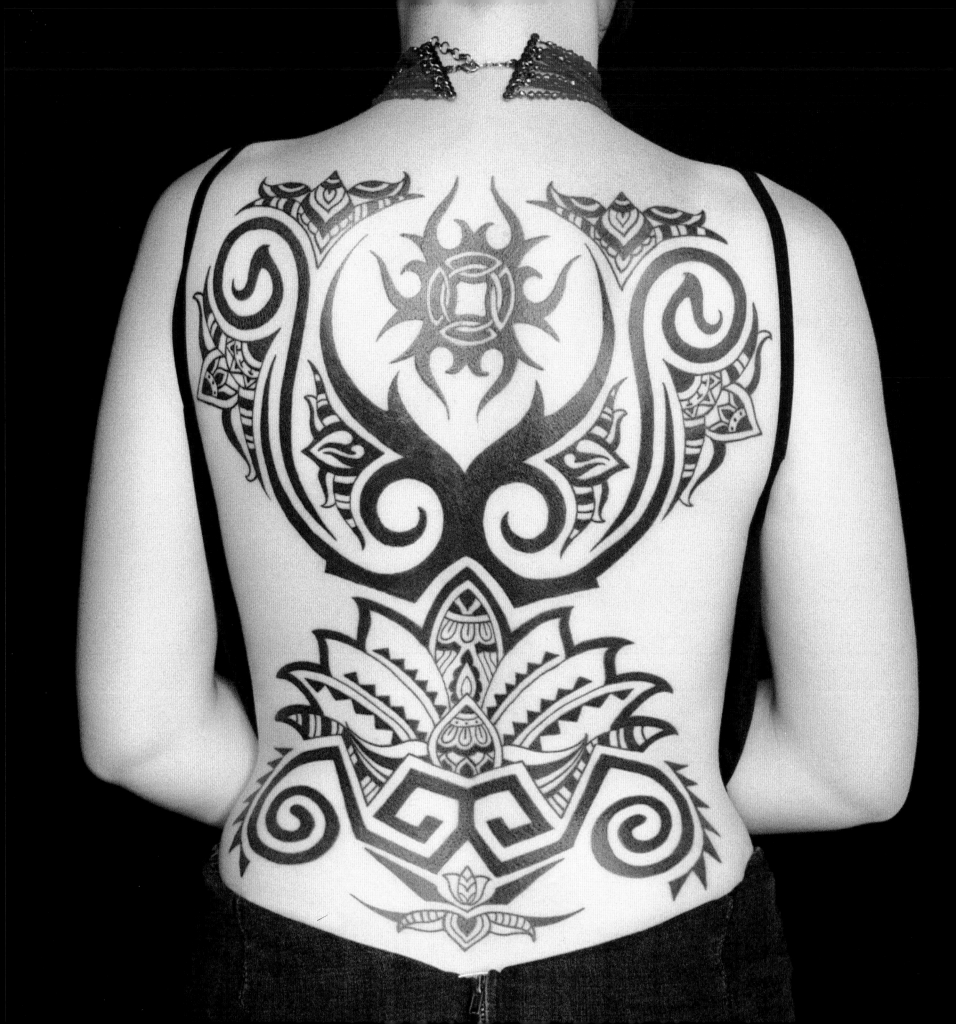

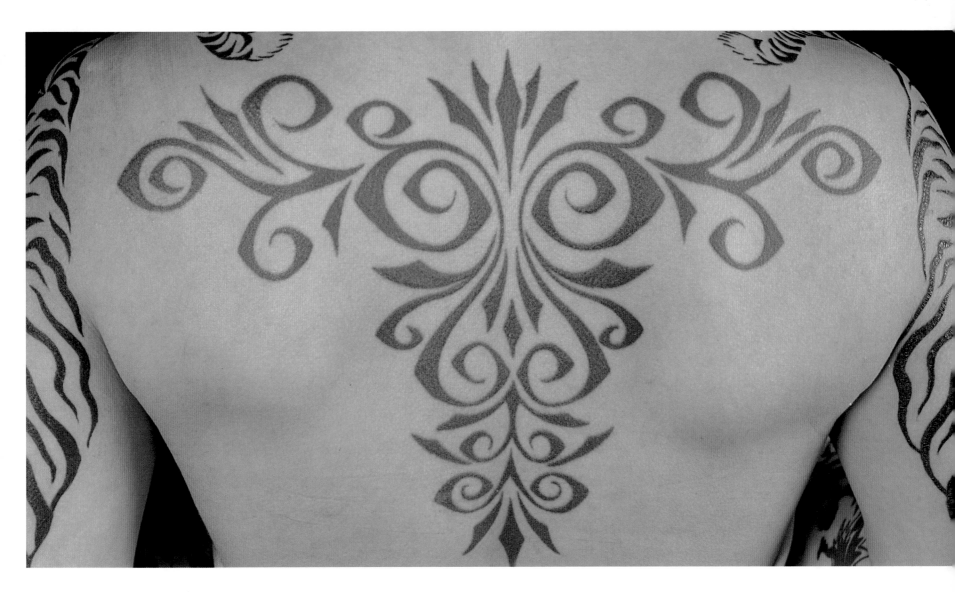

Above: The contours of the back adapt beautifully to black designs and patterns. This is the backpiece of Lisa M. Duhl. More detail of her tattoos can be seen on page 16.

Left: Marie by Calypso Tattoo. This tattoo parlor in Belgium specializes in transforming traditional Polynesian and African tribal art into stunning contemporary tattoo work with a Western interpretation.

returned to Samoa he introduced the use of hammers and sharpened bone or teeth. However it developed (its origins are lost in the very ancient past), tattooing was practiced in nearly all Pacific Island cultures and flourished over any other means of body modification or decoration, including clothing. The warmth of the tropics was the perfect climate for the development of the art of tattoo. In cooler climates, where protection from the elements was necessary, mode of dress was often the marker of status, age, or gender. In Polynesia, however, elaborate tattoos served this purpose instead. Over the centuries, tattooing has been a natural part of life in Polynesia since time immemorial; islanders

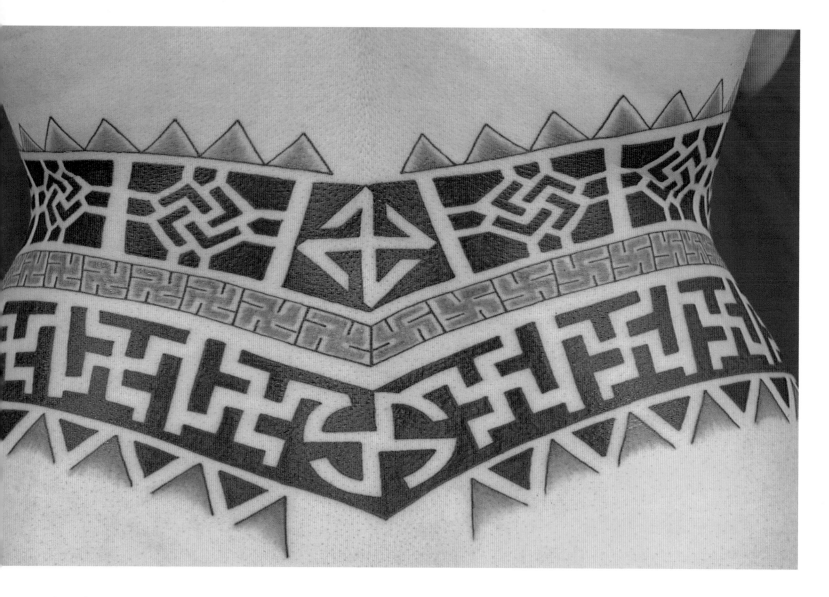

have had the time, the temperament, and the skill to bring it to a high

pitch of perfection.

Naturally, for these people tattooing is far more than merely a

bodily ornament. In the Marquesas, the art of tattooing has always been

deeply linked to the ancient culture and traditions. Men's bodies here,

including the face and even the tongue, can be entirely tattooed with

geometrical signs. On the other hand, women only got the shoulders, the

lower region of the back, the hands, and the border of their lips tattooed.

The exceptional variety of designs are usually related to nature; animals

(turtles, sharks, lizards, or tropical birds), plants (bamboo, cane sugar,

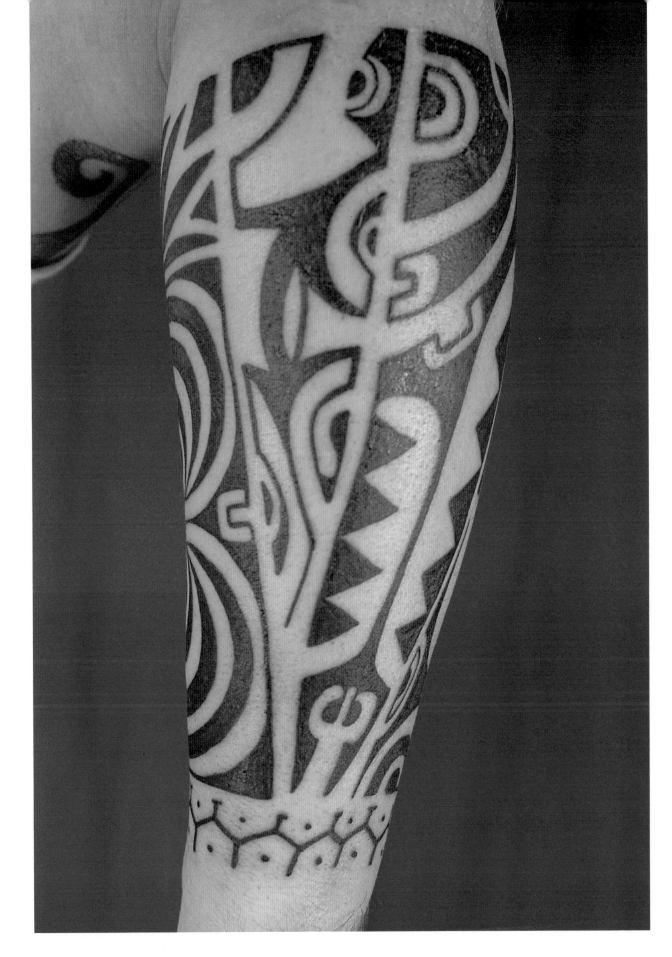

Left: Brett Jones tattooed by Adam Dutton. This beautiful piece places authentic tribal symbolism in a corset-type design that accentuates the waist.

Right: Neil Bass tattooed by Alex Nardini. This is a tribal-style tattoo based on Pacific Island shapes and design patterns.

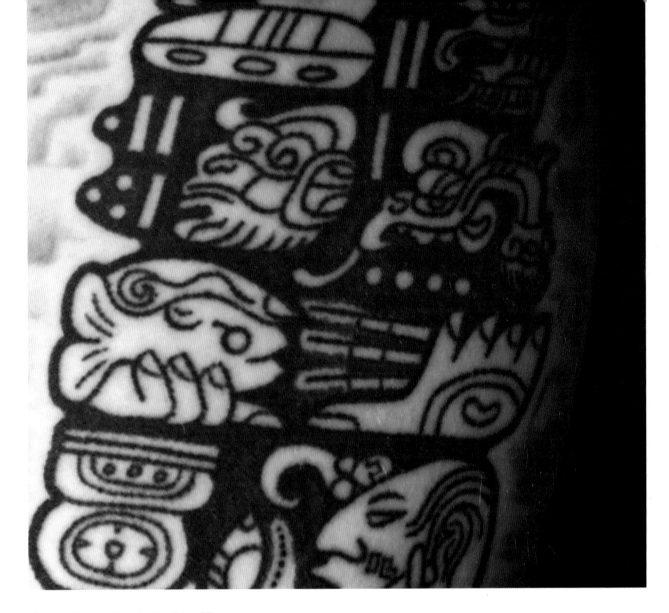

Above: A Mayan tattoo by Pier Tatu of Temple Tatu in Brighton, England. The top four symbols represent the date, while the bottom four show what is taking place along with the client's name, Tom. The hand holding the fish represents "to let blood" in Mayan and to the right there is a hand holding tattooing needles. Pier works in a hand-picking style with needles on chopsticks.

Left: Kirsty tattooed by Nigel Palmer of Temple Tatu, showing dotwork or stippling around the elbow, radiating out into an improvised "doodle." The dotwork is a version of the pointillist style that can be used to create 3D tattoos with few or no lines.

coconut palm, pandanus leaves…), or sometimes to legends or activities like fishing. The most widely spread figure remains the *tiki* whose eyes, nose, or hands could be used separately in the design to obtain a more complicated and unique result.

In New Zealand, Maori warriors were tattooed to appear more threatening. The spiralinear facial tattoos were as characteristic as a signature, and clan or tribal identification was indicated by tattoo motifs. Although the tattoos were mainly facial, the North Auckland warriors included swirling double spirals on both buttocks, often leading down their legs until the knee. As in the Marquesas the women were not as

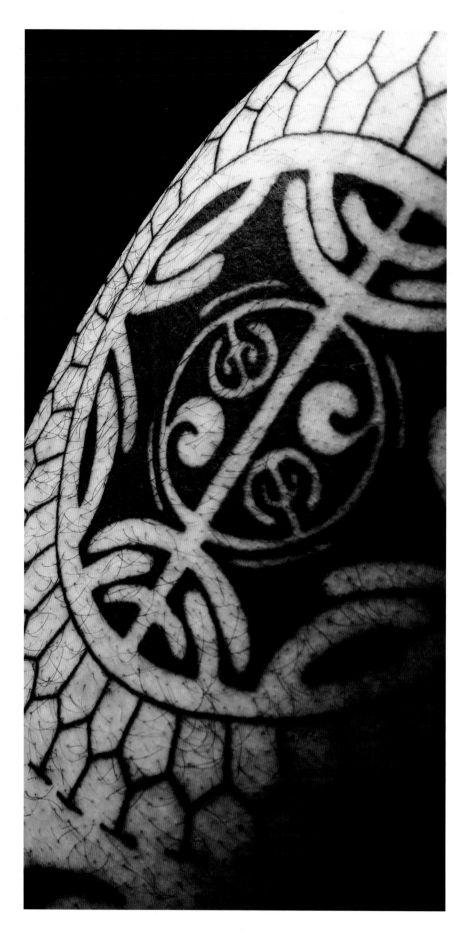

extensively tattooed as the men. Their upper lips were outlined, usually in dark blue and the nostrils were also very finely incised. However, the chin *Moko* was always the most popular design and continued to be practiced even into the 1970s.

In Hawaii, names of the deceased were inscribed on the body, and the tongue was tattooed as a sign of mourning. In many cultures, the chin of a woman was tattooed to denote marriage. On some islands, the vulva was tattooed on the chests of young men at marriage. Small facial tattoos often indicated the lower status of slaves, whereas elaborate full-body tattoos were a sign of wealth, strength, and endurance.

Today, Pacific Islanders are taking pride and interest in their cultural heritage, finding their identity in the revival of many lost traditions including the traditional tattoo. Once again, in the Pacific, the tattoo is recognized as a respectable art.

Back in the West the tribal movement, though still producing some wonderful tattoo work, is now regarded as somewhat less than cutting edge. Its place as the leader of tattoo fashion has been taken by more traditional old-school American styles and Japanese-inspired color work. Nevertheless, watered down flash versions of this most striking form of tattooing have become the choice of the masses. Where once the walk-in

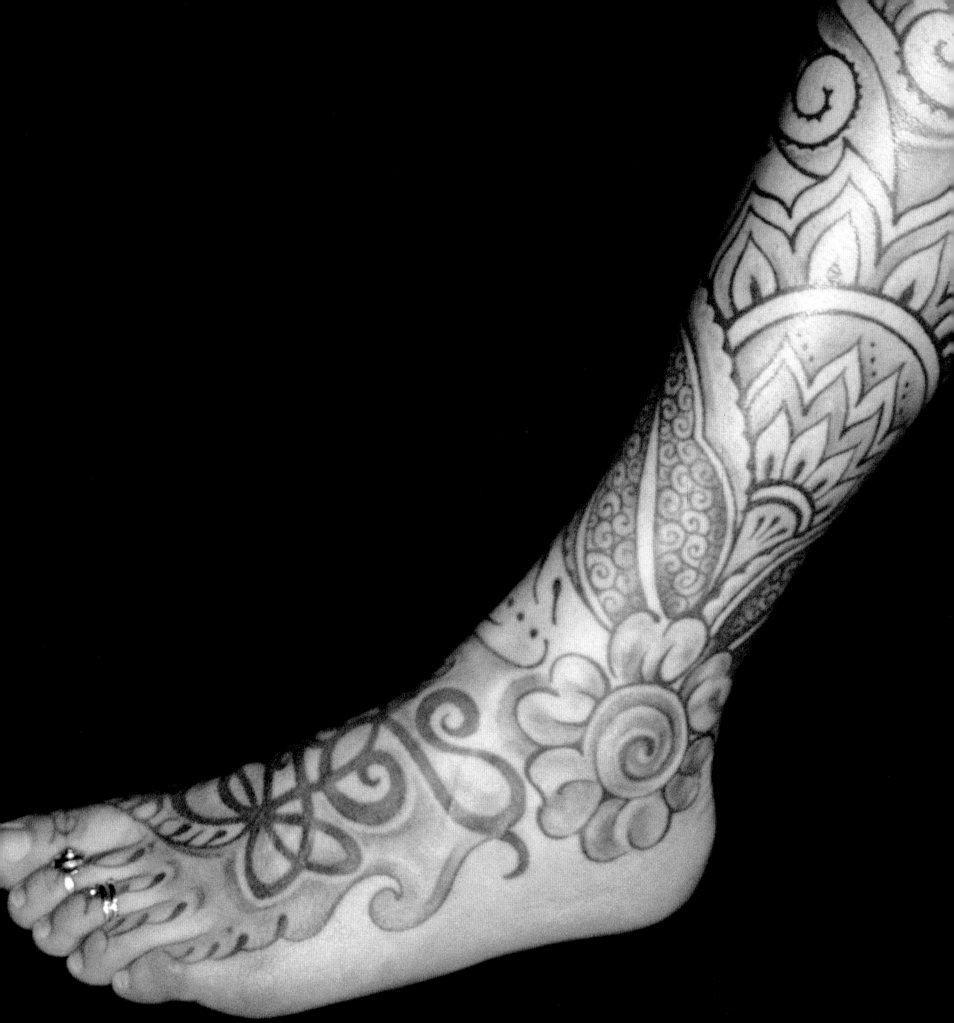

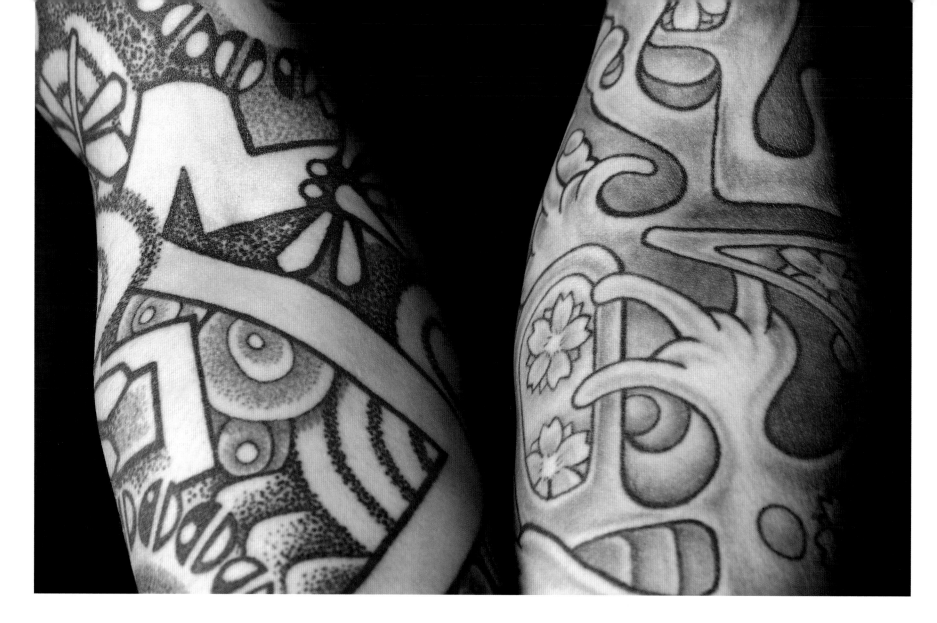

client would prevaricate over sheets of roses with raindrops, hearts 'n' daggers with "your name here," American eagles, British bulldogs, or the national equivalent, now the most popular flash art designs are more along the lines of the Celtic butterfly or the Sepultura tribal style "S." Unfortunately, as with most forms of artistic expression what begins as something ground-breaking and avant-garde, eventually suffers from its own popularity. There are some excellent tribal tattooists out there, true devotees who are pushing the boundaries of their art and if this style appeals to you, it is worth seeking them out rather than picking a vaguely ethnic-looking picture on a flash sheet.

One such new style takes a mathematical approach, using this as the basis for a modern spirituality through science. Combining hand and machine techniques tattooists have created startling new designs—three-dimensional looking geometric shapes and ever-decreasing circles which are both beautiful and speak of new expressions and ideas about our changing relationship with our own universe. Notably, this type of work is being produced by British artist Xed Le Head, though there are others working with the same ideas.

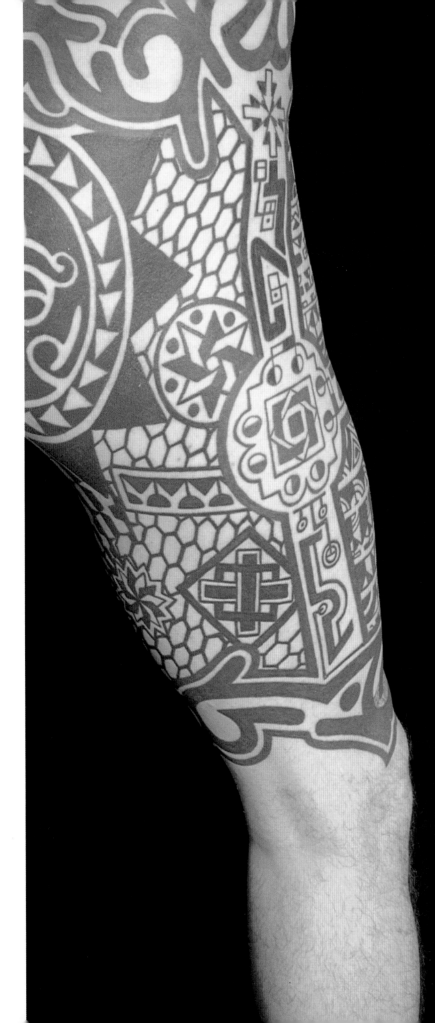

Far Left: Kirsty's forearms. The left is by Nigel Palmer of Temple Tatu, showing traditional *katsumushi* or "win bugs" that appear on Japanese textiles and are associated with Samurai iconography. The right arm is by Ade at Trollspile, Guildford, England, which has elements of cherry blossom and "abstract Japanese water."

Left: Laurent by Calypso of Belgium, a new interpretation of the traditional Samoan "britches" first recorded in eighteenth century ships' logs. The geometric patterns, however, are not traditional Polynesian.

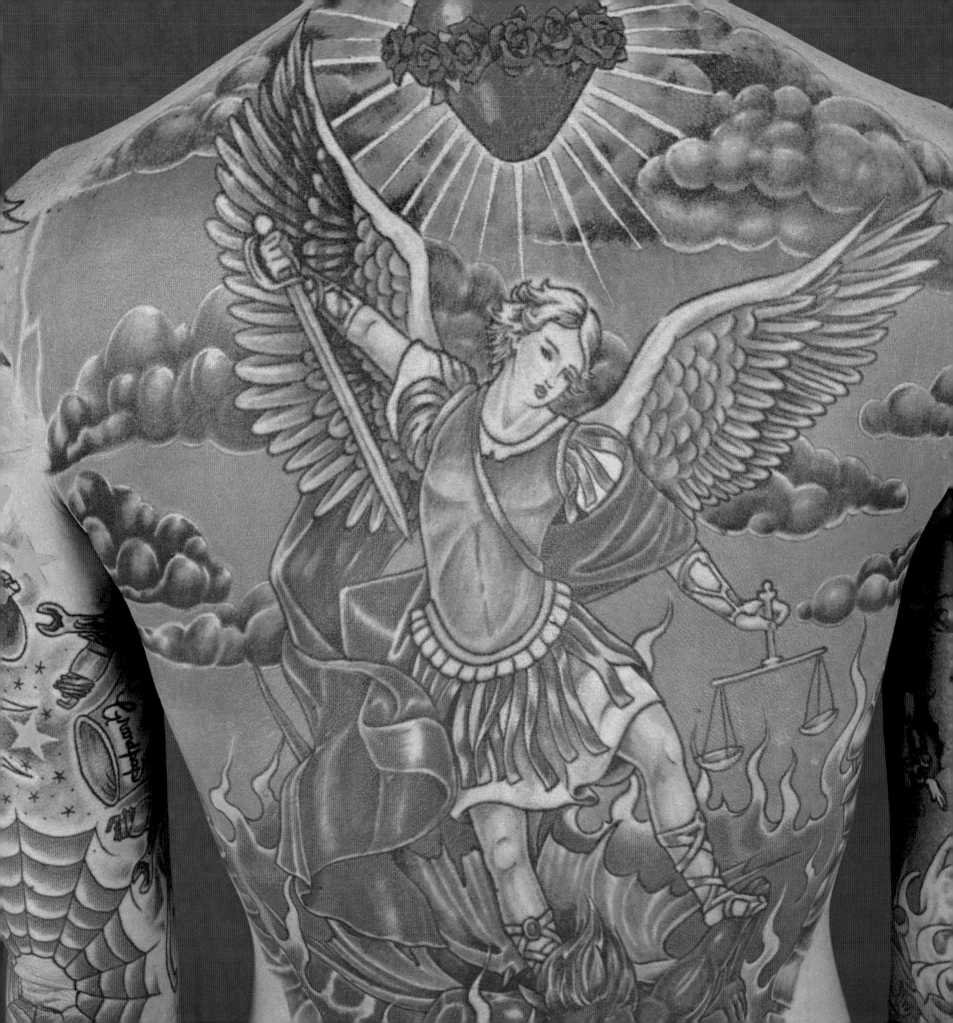

NEW SCHOOL
TATTOOING

Above: Nina Jean tattooed by artists at Thinkin' Ink. New School tattooing encompasses a range of styles and sizes, but is most notable for its vibrant colors.

Left: Michelle Henry tattooed by Chris Henry. Michelle chose to depict St. Michael on her back because of her love of religious imagery and because she was named for him. While religious tattoos are not so popular as in the past, the New School movement makes great use of traditional tattoo subjects.

New School tattooing, as its name suggests, is at the forefront of a new wave in tattoo style. It developed on the West Coast of America and is, very broadly speaking, a combination of Japanese style and traditional old school tattoos; think sailor-style plus. Most significantly, and what sets it apart from either types of tattooing, is its bold use of color.

Left: Cheri Pafumi tattooed by Jim White, Modern Tribalism. This is a classic Sailor Jerry-style pin-up reinterpreted by a new generation.

Right: Lucy by Simon Read at Scribe Tattooing. This sweet tattoo replicates a garter on Lucy's thigh.

Although colored inks have been with us for generations, color work really began to come into its own in the late 60s and early 70s—the time of the psychedelic generation created by children of the 1950s who were raised under the sobriety and conformity that was the hangover from World War II. When the 1960s brought greater prosperity the time was ripe for teenage rock 'n' roll rebellion. As the decade progressed—with the new advancements in travel and communication—the exposure of the masses to the exotic, experimental, and the avant-garde was much greater than in any previous decade. This together with the growing use of drugs, an increased

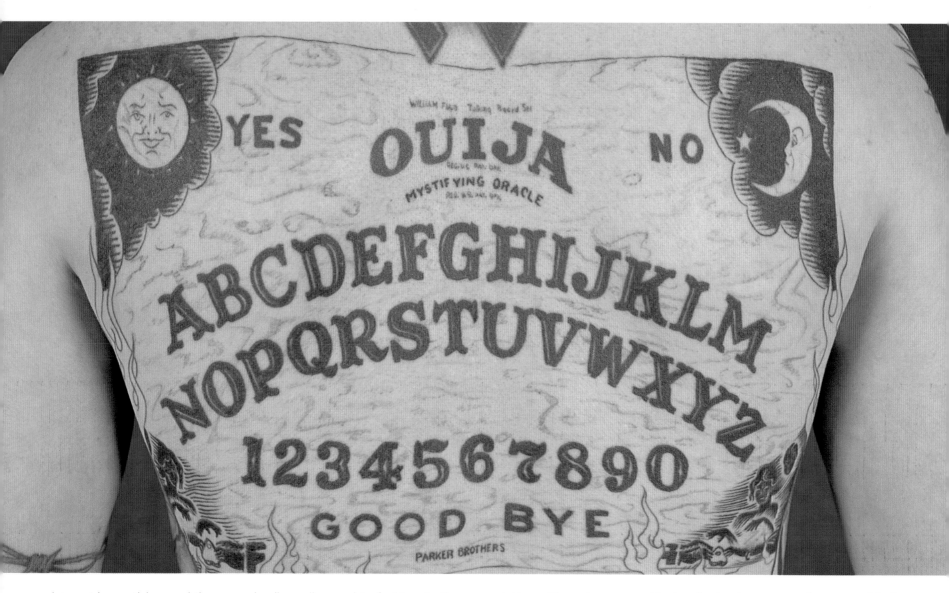

interest in mysticism, and the moon landings, all served to fuel imaginations. The psychedelic universe was born. First featured on album covers, the psychedelic influence was soon everywhere, and in tattooing it was pioneered in the work of the likes of San Francisco's Lyle Tuttle.

Although this was a period mostly associated with the strange and conceptual, it is at this point that advancements in tattooing techniques also made a degree of realism possible. Figures and portraits had always been a feature of traditional work, but it was only now that they began to resemble the ones we see today with their use of color and shading. Where previously the figures had been the familiar simple line-drawn tattoo with perhaps some blocks of color, it was now almost possible for artists to draw in flesh as they would on paper. The popularity of this practice has its roots in the "remembrance" or "tribute" tattoo, where a likeness of a loved one (living or deceased) would be tattooed on to the body so that the wearer might always carry something of them to remember. Such tattoos are all about the protection that your loved one will give you and also create an illusion of togetherness. The same rationale accounts for the many images of Christ and the Virgin Mary that have been a staple of tattooing for generations. This type of work can be seen more extensively in times of war for obvious reasons. More recently, however,

Left: John Barrows Jr. tattooed by Al Benendetti, Julie Moon Designs, Seabrook, New Hampshire. John and his tattooist are both fascinated by horror movies and decided to tie his horror-themed tattoos together with a Ouija board backpiece. Despite the lack of color, this tattoo is a descendant of "American manner" tattooing which often used text in fancy scripts with decorated surrounding borders.

Right: Emily Roberts, artist unknown. This is an excellent example of a tattoo made solely with white ink, which is very uncommon. Drawing on tribal themes it is much more delicate and discreet than blackwork and is a very feminine tattoo.

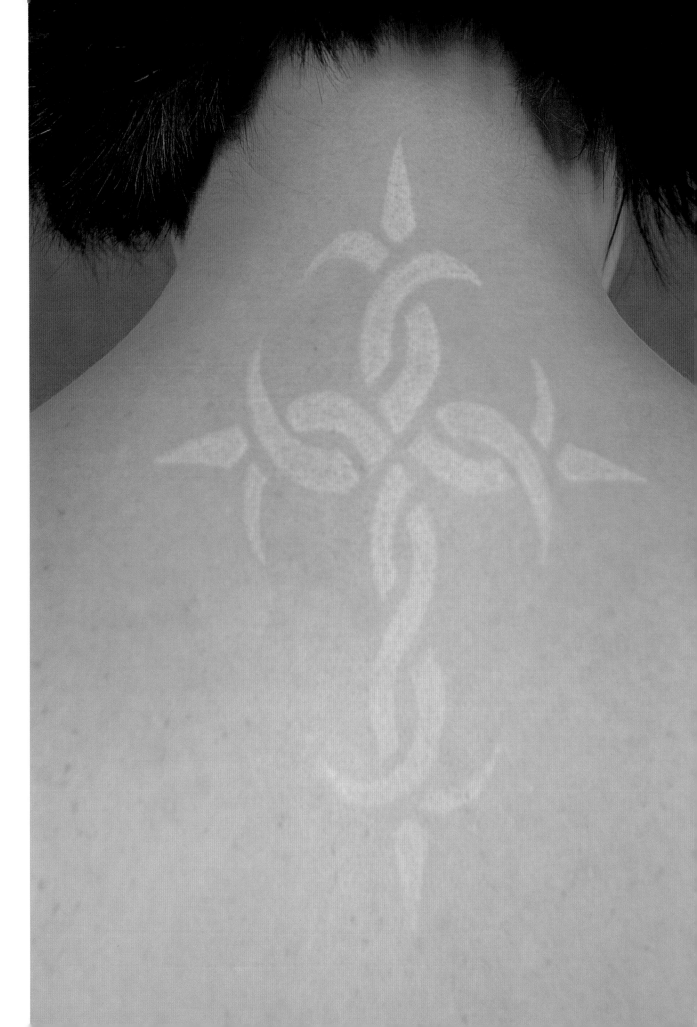

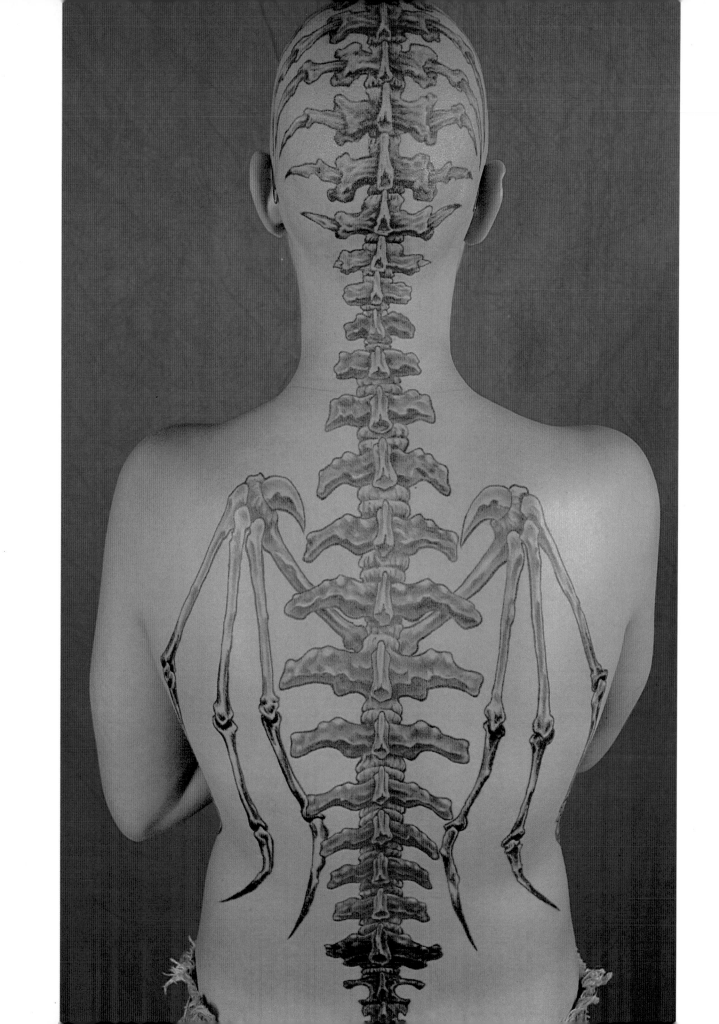

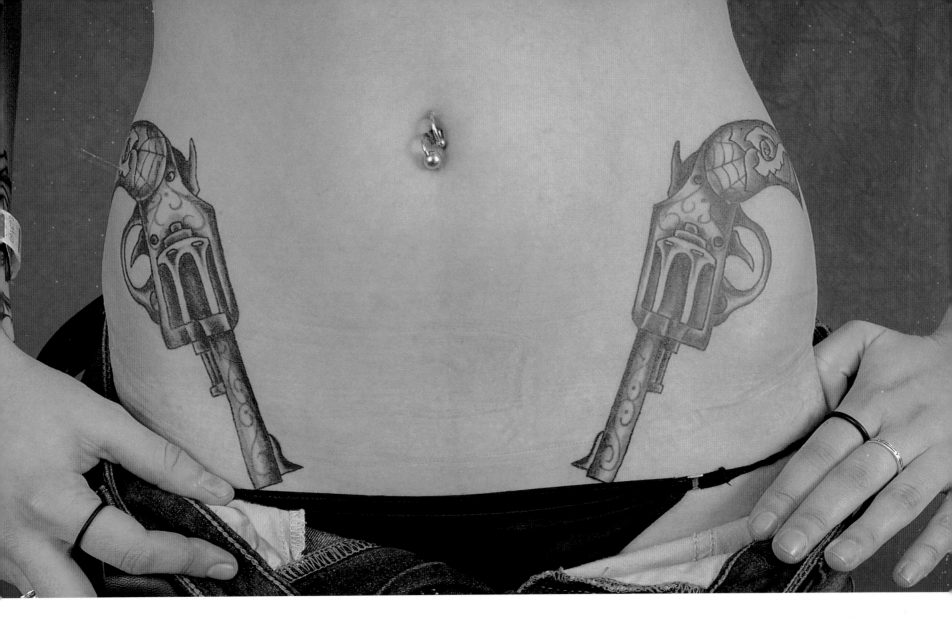

there has been less of a demand for religious tattoos or images of loved ones and more and more they might depict actors, actresses, musicians, and other celebrities—not entirely surprising with the almost religious fervor directed toward many stars. It is worth mentioning that however worthy or otherwise the subject of the tattoo might be, the skill involved in producing the best examples of this work is undeniable.

Following the revolution in color work of the 60s and 70s, the 1980s saw tattooing fall stylistically into a kind of no-man's land. There was no dearth of new styles or techniques being worked at, but neither one was more prevalent than the next. However, this decade is arguably where

Above: Kim Sikorsky tattooed by Rev. Bob Knox, Enigma Studios. Similar in feel to the garter on page 93, "holstered" pistols seem to be gaining popularity in the tattoo world. This pair of six shooters is a superbly executed example.

Left: Kim Stivers tattooed by Tim Kohtz. These skeletal demon wings were inspired by the 80s fashion for making a terrifying tattoo that appeared to be a part of the body.

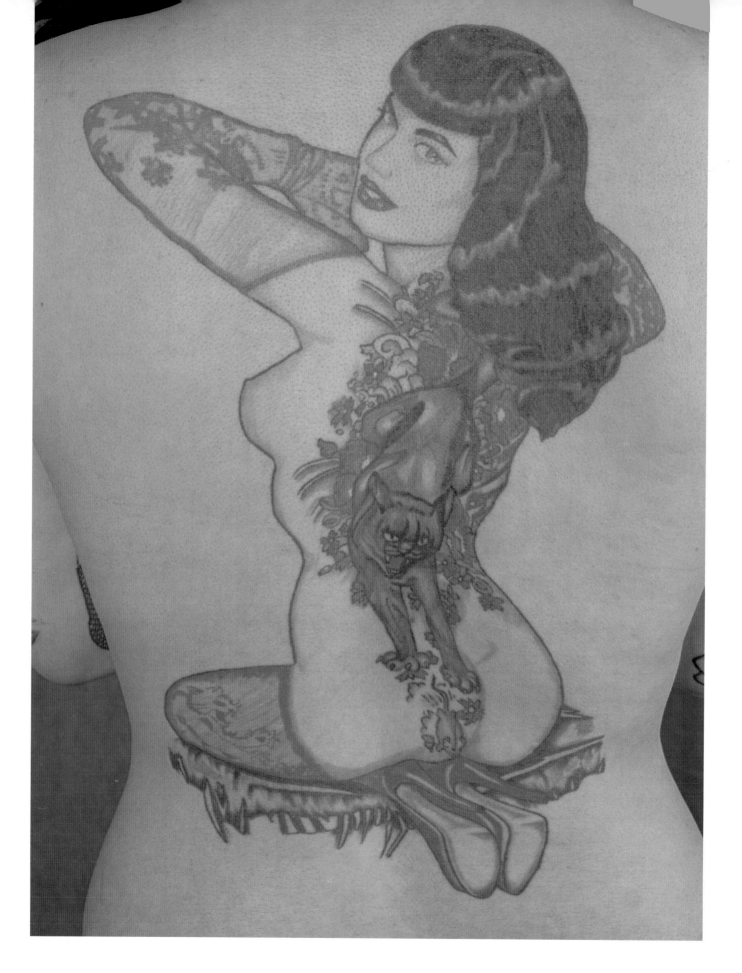

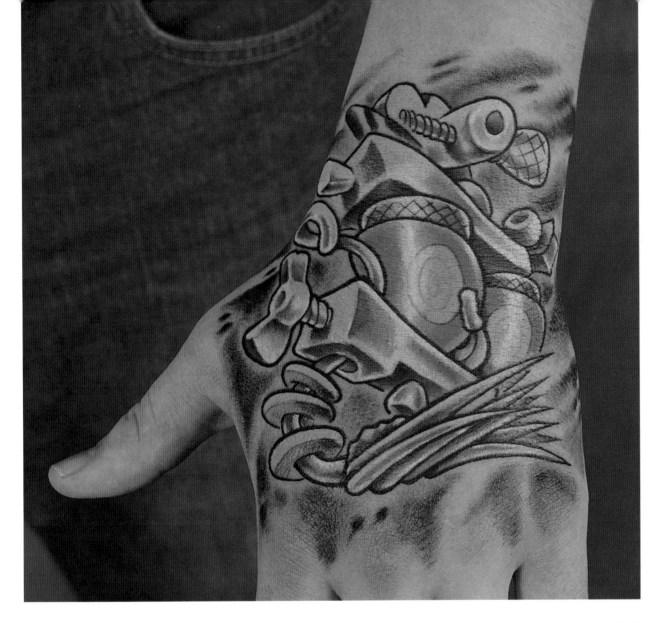

Western tattooing began to come into its own. Artists were quietly developing the skills that would make the following decade's explosion of style possible. If anything, this was the age of the heavy metal tattoo, with many requests for Iron Maiden's "Eddie." With the screening of H. R. Geiger's *Alien*, biomechanics was also born and the idea of integrating man and machine became a form of horror tattooing. New York's Paul Booth was one of the most successful at bringing a profound level of realism to this genre and images of peeled away flesh revealing mechanical workings beneath became quite popular during this period.

This brings us to the 1990s and the advent of the "modern primitive" movement discussed in the previous chapter, a term coined by cultural philosopher Levi Strauss in a book commenting on the trend for tribal tattooing and body modification. However popular though, strong expanses of black ink weren't for everyone. Also during this period the allure of rap and hip hop music had began to increase and with it graffiti art. So, while some disaffected youth were getting themselves inked like the Marquesians, stretching their ear piercings and hanging themselves from hooks, others were painting trains and tagging walls. Graffiti, once regarded as purely public nuisance and vandalism, was starting to be seen as an art form in its

own right and soon found its way into tattooing. To quote Alex Binnie, the tattoo artist: "Tattooing attracts the young, it's a vibrant street-art like graffiti. If kids can get a hold of start-up kits they are going to. I don't want to encourage that, but it's inevitable. Let's face it, some of the best tattooing is done in unlicensed conditions by young artists who are really passionate, tattooing away in someone's bedroom at three in the morning." Combine this creative passion with elements of traditional work and Japanese composition and you have something of the premise of New School tattooing. In short, it can be seen as a kind of Westernized take on Japanese tattooing. Developing in tandem with the tribal movement,

it is now the basis for many of the vast array of styles across the U.S. and Europe.

Although it has always been a part of the New School mix, more recently we have seen a stronger return to the Western traditions of tattooing. This type of traditional tattoo is very stylized, quite two dimensional, and often executed with little regard for art. The lines tend to be thick and bold, the colors are rarely shaded or lifelike, and the images tend toward iconic and cartoon-like with little effort made to make things look realistic. This was a relatively quick way to tattoo and came into its own in the 40s and 50s near military bases where, unlike the world at

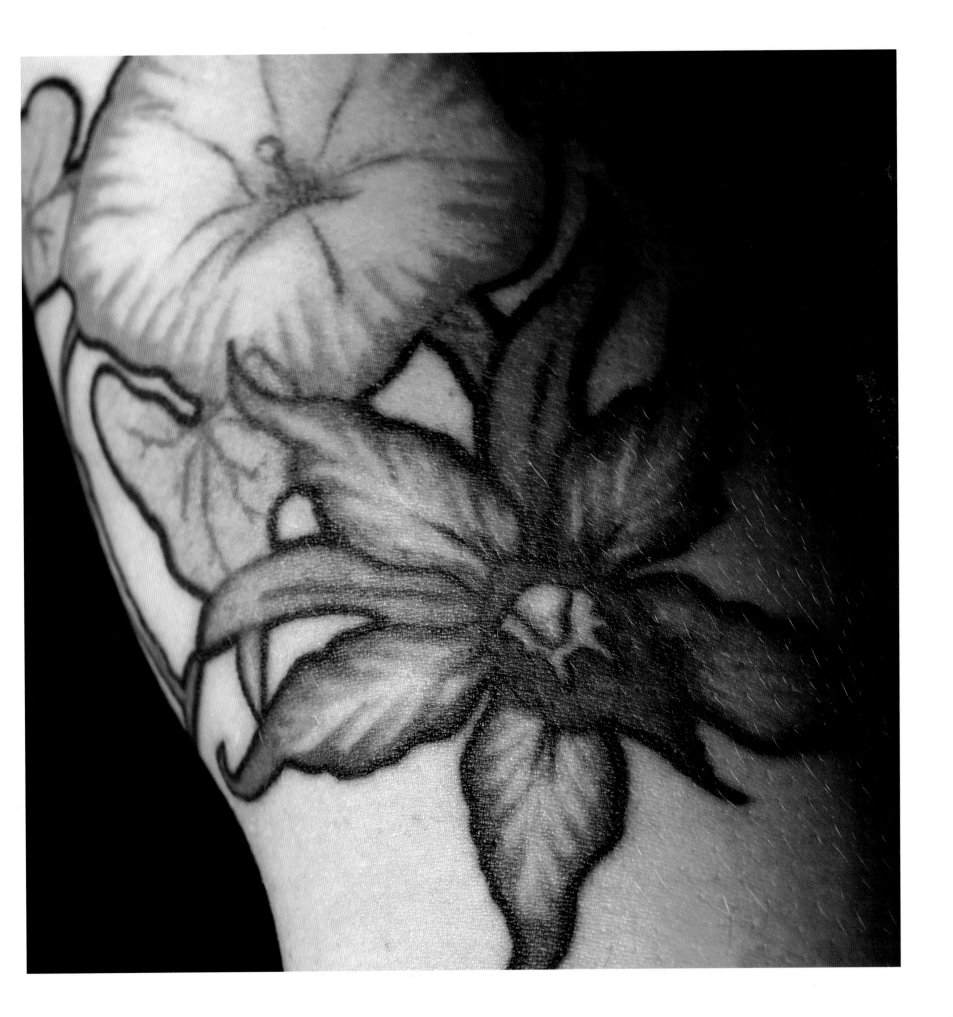

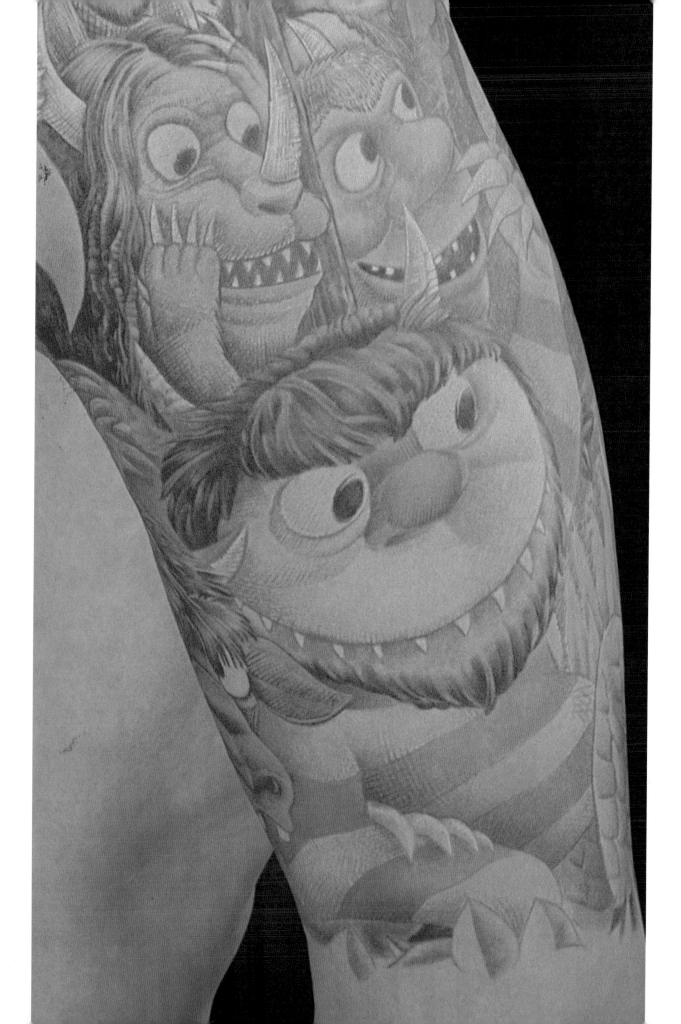

Left: Lyndsey Hahn tattooed by Monte, New Breed. This extensive tattoo is a depiction of Shel Silverstein's children's book *Where The Wild Things Are.* This is a work of considerable devotion and expense, but is notable for its dramatic use of color and amazing detail.

Right: Sharon A. Trainor tattooed by Dan Carroll, Masterpiece, Salem, New Hampshire. This tattoo depicts Sharon's grandmother reading to her granddaughters and how their imaginations interpreted the story. This is a modern example of the "remembrance" tattoo, which is an indelible reminder of a loved one. These days, however, the image is likely to be much more photo-realistic than in years past. To make an accurate portrait as a tattoo involves great skill, but the result is likely to be highly personal to the wearer.

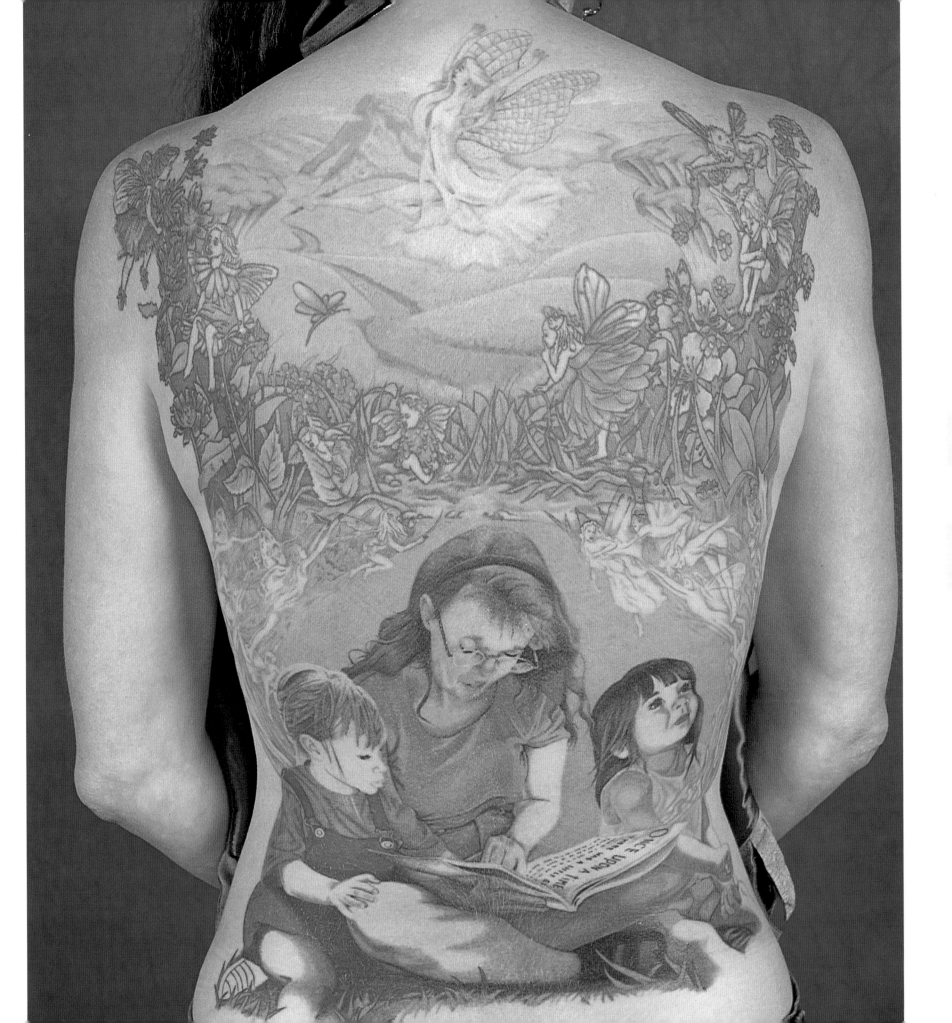

large, there was an unusually heavy demand at this time. The tattoos were colored using the limited palette then available, predominately black and red. Common design elements included arranging scrolls of words among decorative vignettes, flowers, anchors, hearts, birds, and animals. Originally the preserve of soldiers, sailors, criminals, and sideshow performers, today the proudest exponents of this kind of body art are punk kids and musicians. And, for a change, the movement is now taking its lead from the East Coast of the U.S. While it always comes down to personal choice, it is worth mentioning that among devotees there is also a move toward greater coverage—hand and neck work is no longer out of bounds.

Above: Clare Jordan tattooed by Eric Merrill. Both this tattoo and the one opposite are remarkable reworkings of traditional imagery by New School artists. Clare believes in tattoos that correspond with your life. The yellow roses in her chestpiece represent the last flowers that she gave her grandmother before she passed away in a hospital.

New York tattooing never broke away from its traditional beginnings completely. With the use of strong graphics, often accompanying wording, for a time the New York artists were often accused of being gratuitously aesthetic with their bold use of heavy shading and strong color. But the best examples of this new style old school tattooing (so to speak) differ from their origins in that they are expertly executed with a highly considered appearance. The tattoos are largely of custom design. This can be seen as modern tattooists picking-up where the famous sailor Jerry Collins left off. Collins was noted for striving to introduce a greater level of quality to traditional style, bringing an element of Japanese quality

Above: This tattoo by an unknown artist takes traditional nautical themes of anchors and mermaids and gives them a modern twist, not least in the tattoo being worn by a woman. The coloring is also exceptional.

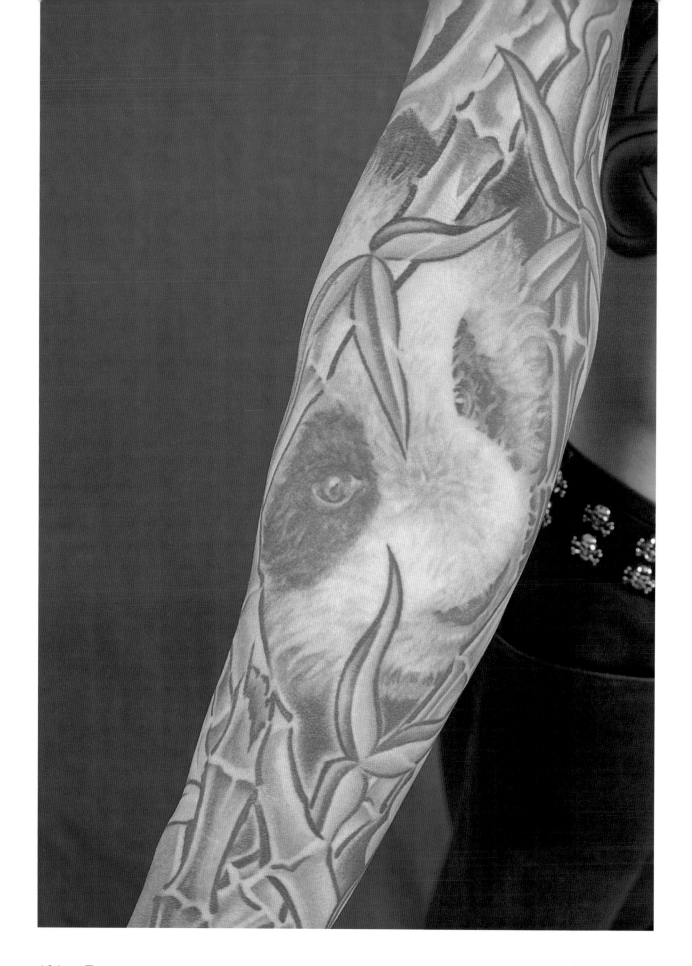

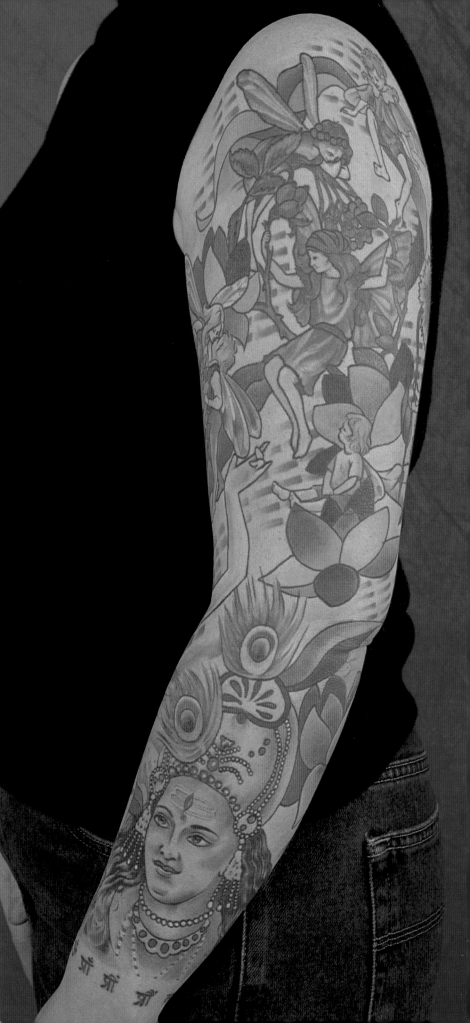

Left: J. Green tattooed by Dawn Purnell, Four Star Tattoo, Santa Fe, New Mexico. This photorealistic tattoo of a panda bear would have been impossible with the equipment available to previous generations of tattoo artists. With technology improving all the time, the future for tattooing is limited only by the skill of the artist and imagination of the client.

Right: Christina Richardson tattooed by Sarah Peacock, Jade Monkey Studios. Once a profession held mainly by men, more and more women are becoming tattooists today. Well able to hold her own against any man in the field, this tattoo is a good example of Sarah's big, bold work, combining mythological beings from varying cultures.

to the work. However, the return to the old school has not seen a return to flash work.

So where does tattooing go from here? Well frankly this is anybody's guess. There is a school of thought that believes that with the current trend toward greater coverage and an appreciation for traditional work, we'll see a more savage, less aesthetic style emerge, more akin to the old prison style or sideshow performer tattoos, and similar in style to some of the more extreme work of Mr. X. It would make sense given tattooings new face of acceptability. Having previously been the preserve of the outsider, what better way forward for those who want their tattoos to give them a little bit of

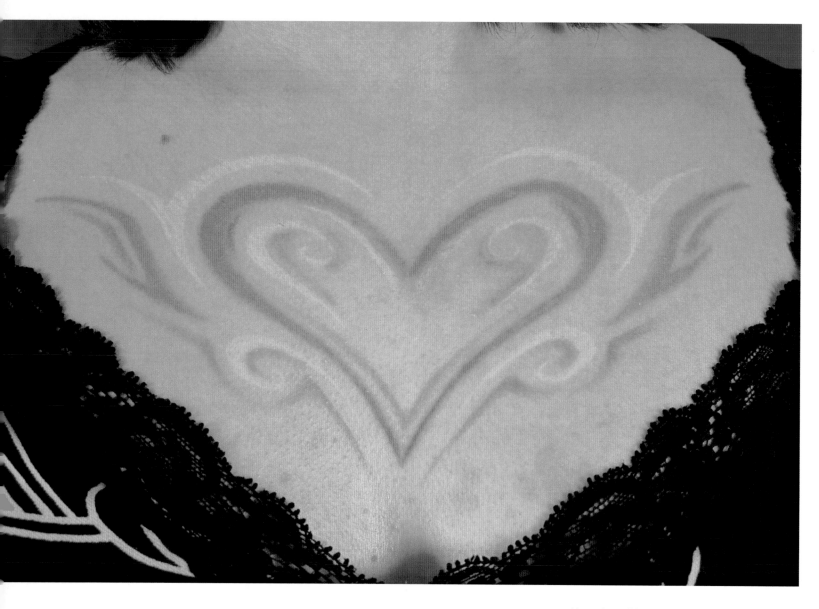

Above: A traditional theme in a modern style.

Right: Gil Blovin tattooed by Avashai Tene, Israel.
A strikingly individual backpiece in terms of both
subject matter and use of color. It depicts
Alexander the Great.

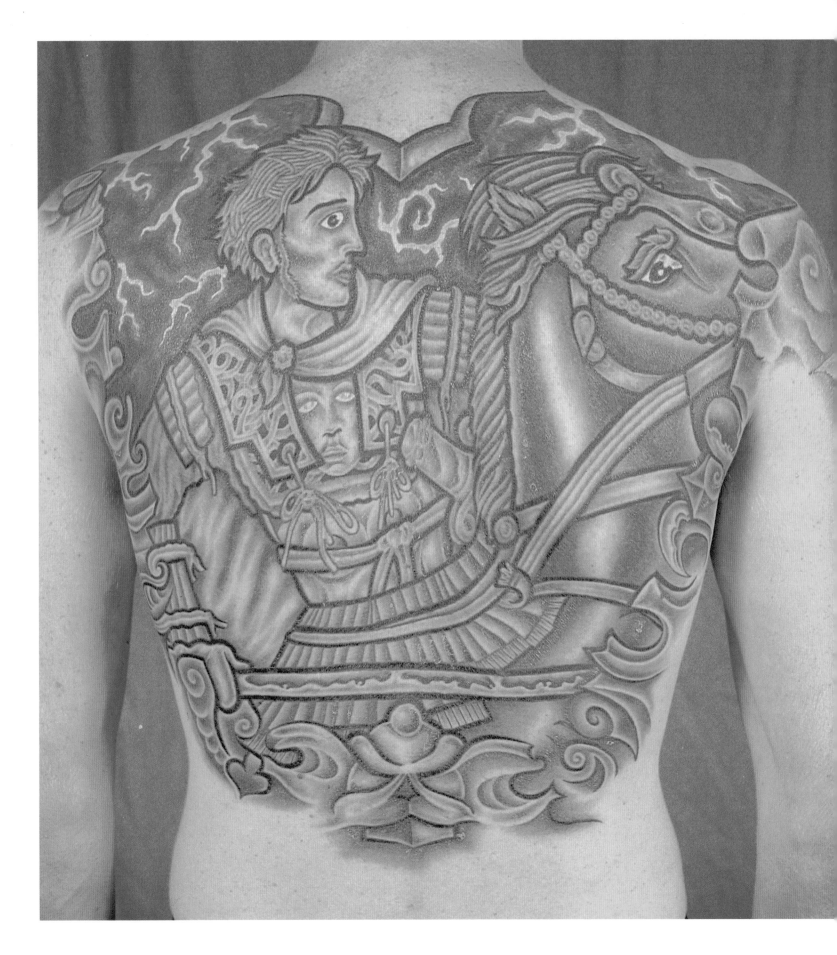

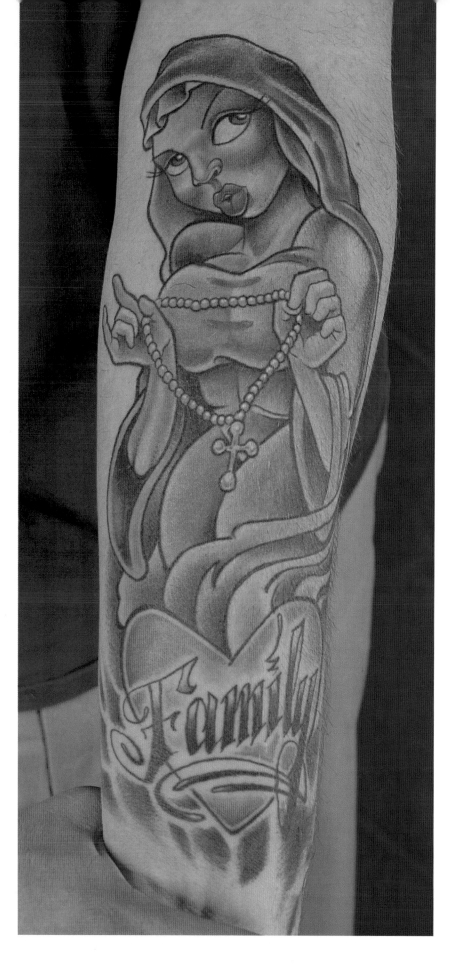

Left: Jason Tritten tattooed by Jim Litwalk, Electric Superstition. Jim is known for his New School cartoon style, which incorporates elements of street art and old style tattooing. This tattoo is a quirky take on old style religious tattoos.

danger than to add chaos to the mix? Just when we are becoming comfortable looking at tattooed skin and those exhibiting it then there are those that would continue to challenge the fashionable images and ideals that have recently been created, pushing tattooing back toward the peripheries of society.

To conclude it is worth mentioning just a few of those tattooists who have recently pushed the boundaries of their art. Although it is impossible to mention all of those who have helped to bring tattooing back into the public conciousness and make it the dynamic art form it now is, these brief biographies show just how diverse the tattooing world is and how very far the artists are from the old public perception of seedy tattooists in dirty parlors, tattooing worthless images onto social outcasts.

Whereas some tattooists focus almost exclusively on their tattoo work as their chosen form of artistic expression, Guy Aitchison moves in and out of different media as need be, whether it be tattooing, painting, or writing. He sees being an artist and getting tattooed as having almost unavoidable consequences, and from his own background painting record covers, Guy started apprenticing at Bob Olson's Custom

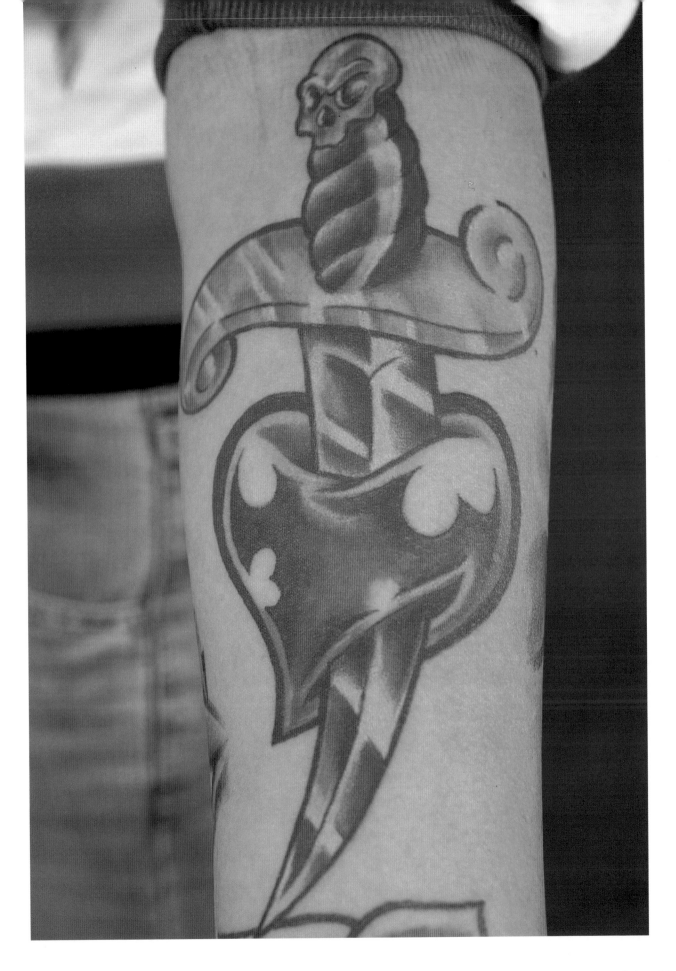

Left: Goska tattooed by Bugs, Juan from Angelic Hell, Matt from Tusk. This is traditional tattoo subject matter depicted in a style not often found outside of a canvas or subway wall.

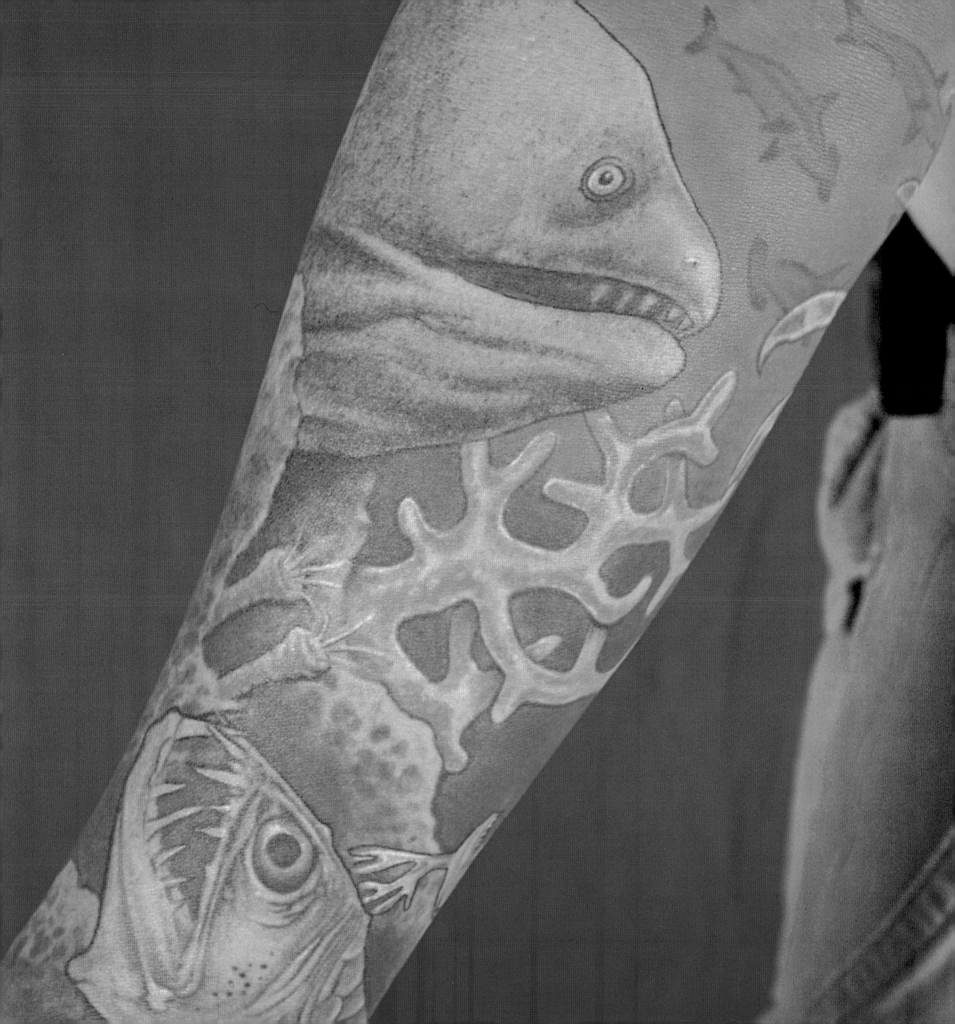

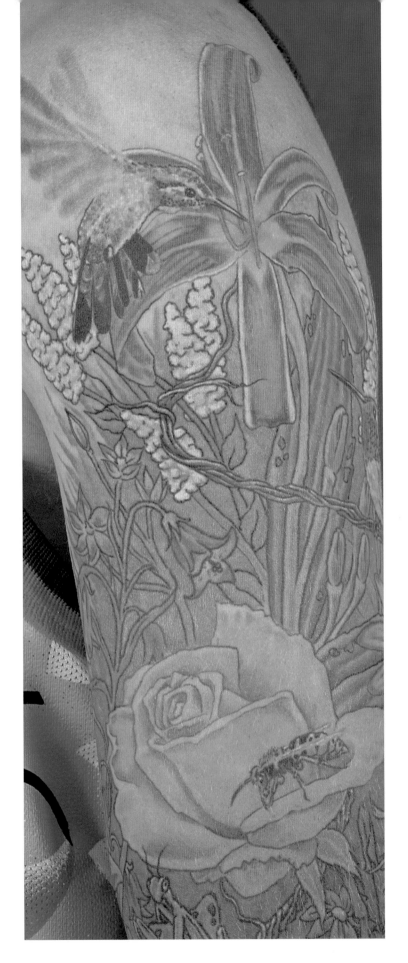

Far Left: Britt Davis tattooed by Mike Parsons. This is a realistic underwater scene that incorporates all of Britt's arm.

Left: Mike Racicot tattooed by Mike Andrews, Fantality Tattoos, Peterborough, U.K. An amazing wildlife scene with elements of the English garden (the rose and bee) as well as tropical flora and fauna. The overall result is colorful and beautiful.

Tattooing in Chicago in 1989. Two years later, he opened his own shop under the moniker Guilty and Innocent Productions, only to close his doors in the mid-nineties in order to move away from the urban environment and have the ability to pursue other means of expression. He sees the balance of different artistic media as an integral part of avoiding getting burnt out on any one medium. Still tattooing at home and on the road, he finds himself in a constant state of flux, learning from everyone he comes in contact with, regardless of their experience level. Although considered an innovator and master

of the tattoo medium, he sees himself rather as a catalyst for change; the driving force for that change comes from within the entire movement itself. He says that "...true mastery can exist only in theory, and... our limitations as human beings make us perpetual students." As a student of life and art, Guy's inspirations reflect his varied interests: Salvador Dali for his work ethic, high technical standards, and sense of humor, H.R. Giger for his organic forms, Alex Grey for a sacred presence, and M.C. Escher for his multi-dimentionality. These influences can be seen in his work; exploring the organic form, which he sees as both simple and infinitely complex, allowing an understanding of light, form, and composition.

Above: Debra Blue tattooed by Shane Watkins, BellaDonna Tattoo, Austin, Texas. Inspiration can be drawn from a myriad of artistic sources. This rose is in a style pioneered by the Arts and Crafts movement of the early twentieth century.

Right: Angie Mitchell tattooed Chad Wells, Glenn Scott's, Dayton, Ohio. This tattoo is a New School gambler's delight incorporating good luck symbols such as the horseshoe, dice, and number seven, as well as a sailor-style inspired pin-up girl.

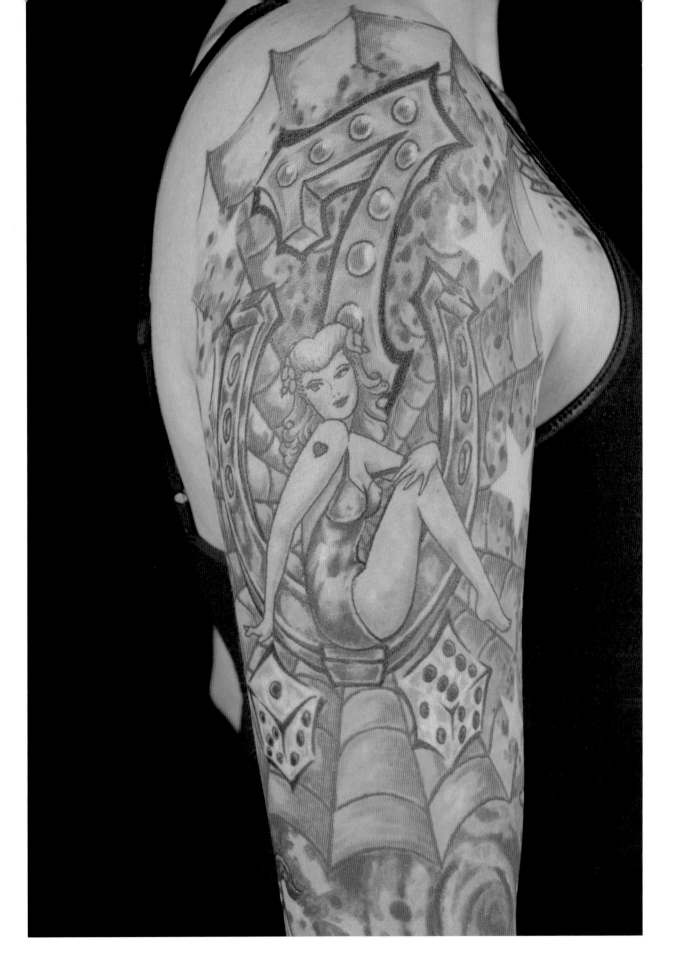

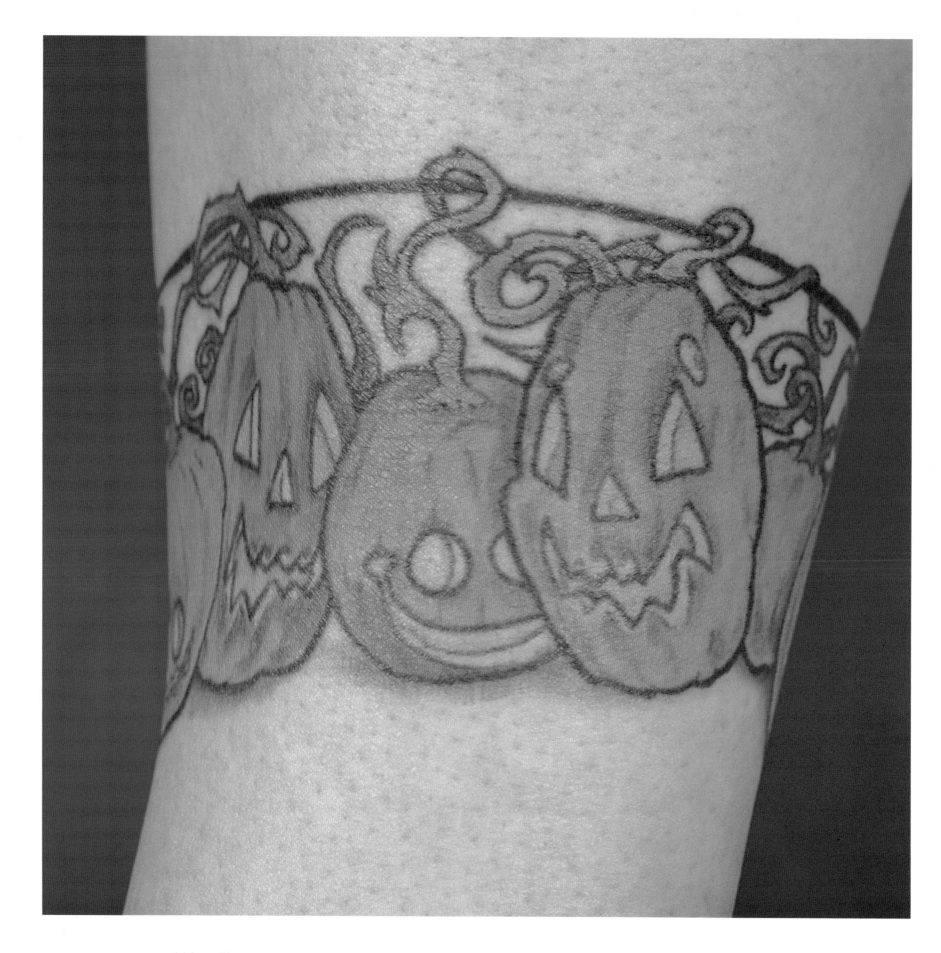

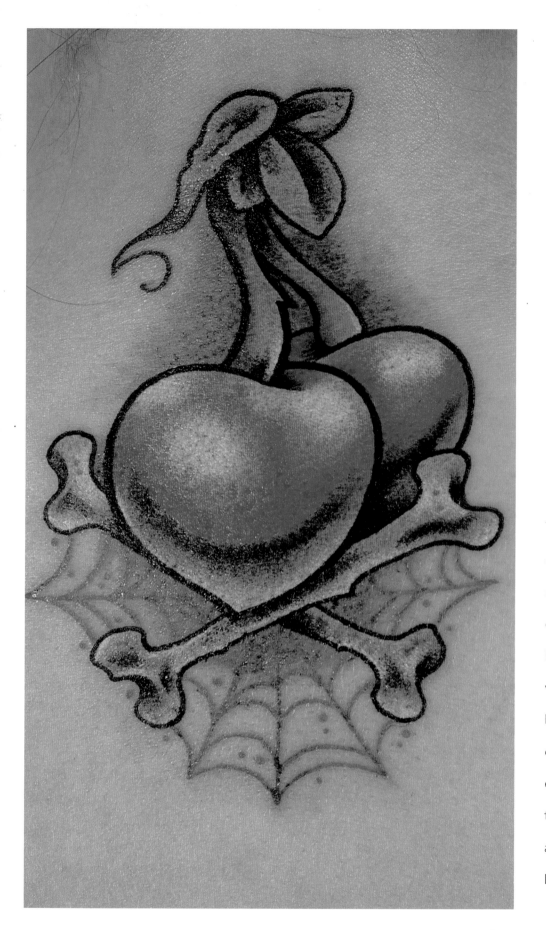

Having been raised in Perpignan, France, in the Catalan culture that influenced artists like Picasso and van Gogh, it's no surprise that Bugs (born Pascal Jarrion) has recently turned to art movements such as Cubism for inspiration. After attending art school and completing his compulsory service in France, Bugs moved to London, believing there to be more opportunities there as a professional tattooist than at home. This proved to be the case, and after two years of working for others, he opened his own shop while still in the process of refining his craft. After a period of constant drawing and creating custom designs, Bugs made a name for himself as the King of Celtic. Being highly in demand for years in this capacity, when he was finally able to find the time to pick up a paint brush, he felt it was a natural progression from the thick outlines and softly angular shapes of Celtic knotwork to parallel elements in Cubism. This exploration of painting techniques, in turn, influenced his tattoo work, and he started to incorporate a mix of Cubism, Art Deco, and Classical art into his designs. Like most artists of worth, Bugs is his own harshest critic,

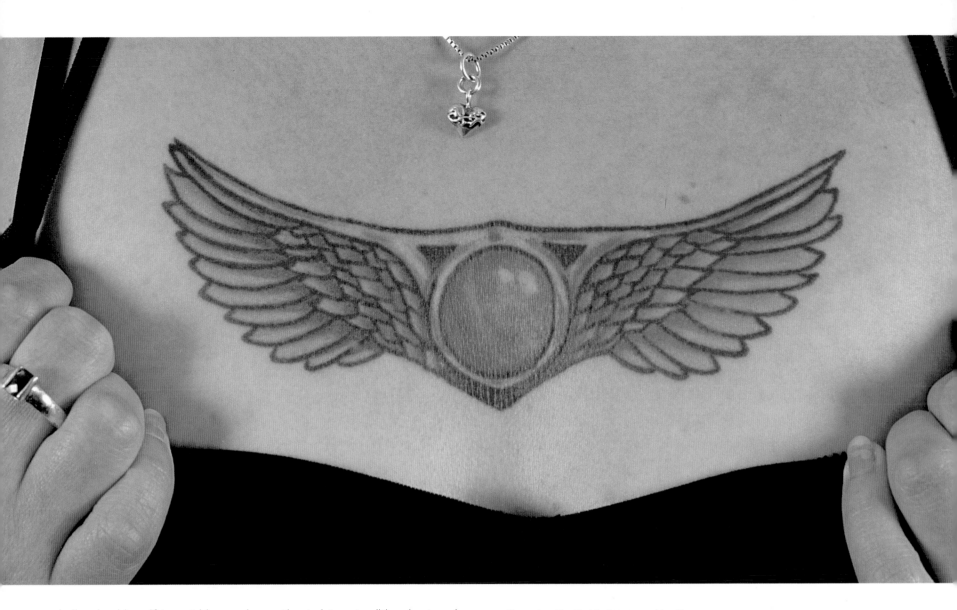

Above: Jennifer DeNault tattooed by Dave Heroald. A simple design with an ancient Egyptian flavor, beautifully colored and shaded.

challenging himself to put his own innovative twist on traditional art, and finding inspiration from artists outside of the tattoo world, such as Picasso and Braque. Making inroads into the world of fine art, Bugs foresees himself in ten years doing just what he's doing now—remaining true to tattooing as his first love and what he sees as the best thing that's ever happened to him, as well as pursuing his painting as the logical progression of his artwork.

With a degree in criminal justice and a respectable career designing security programs for hotels, why would anyone take a chance on starting a new career as a tattooist? Well, that is just what Tom Renshaw did, and

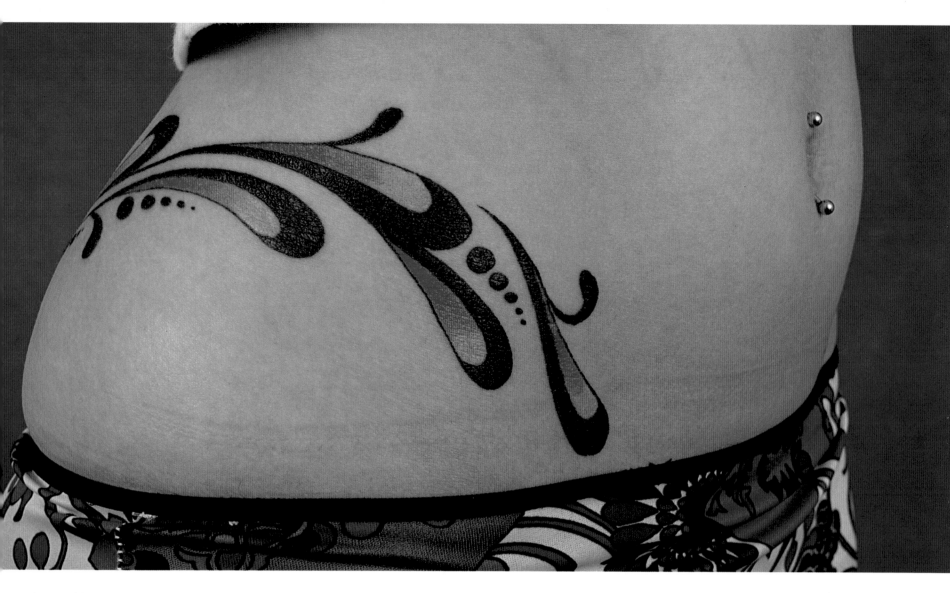

the gamble certainly paid off. Now known worldwide for his realistic

portraits of people and animals, Tom got hooked when he took his

former wife to get tattooed. It was time for him to trade in his suit and

tie for a tattoo machine. Although he had no professional background as

an artist, as a child he had had quite a talent for drawing and copying

photographs that had laid dormant while he worked the nine-to-five

grind as an adult. Luckily, like riding a bike, the talent was never quite lost

and Tom found the same attraction to photorealism as a tattooist as he

had as a kid. Having been tattooed by Brian Everett also informed his

artistic direction, and he started out gravitating toward portraiture.

Above: Natalie Norbeck tattooed by Cory Ferguson, Way Cool Tattoos, Oakville, Ontario, Canada. This tattoo owes more to tribal tattooing than to traditional. However, its design is purely abstract, though this does not detract from its impact. The flowing, organic lines across the rounded hip make this a striking tattoo.

Although he still does his fair share of portraits of people, he finds that the challenge in depicting the variety of skin and fur textures found in the animal kingdom serves to increase his flexibility as an artist and push the technical aspects of his craft. On the interpersonal side of his work, he feels that not only is the act of permanently altering one's physical self an emotionally and spiritually charged experience, but when a person requests a portrait of a loved one, whether man or beast, it adds another aspect of emotionality that binds him to his client. Even when someone asks for a tattoo of a wild animal, Tom encourages them to research that particular animal, bring him photos, and become part of the process that brings an exotic animal from the wild into the immediate proximity of their skin.

At age seven, Bob Tyrrell's future was starting to take shape, as he began to collect monster magazines such as *Creepy, Eerie,* and *Famous Monsters of Filmland,* as well as *Mad* magazine. With his artist father and fantasy artist Frank Franzetta as influences, you'd think Bob would have been off and running, but instead he picked up a guitar as a teenager and spent the next fifteen years playing rock and roll. At age thirty, after much deliberation, he got his first tattoo, and that experience reignited an early

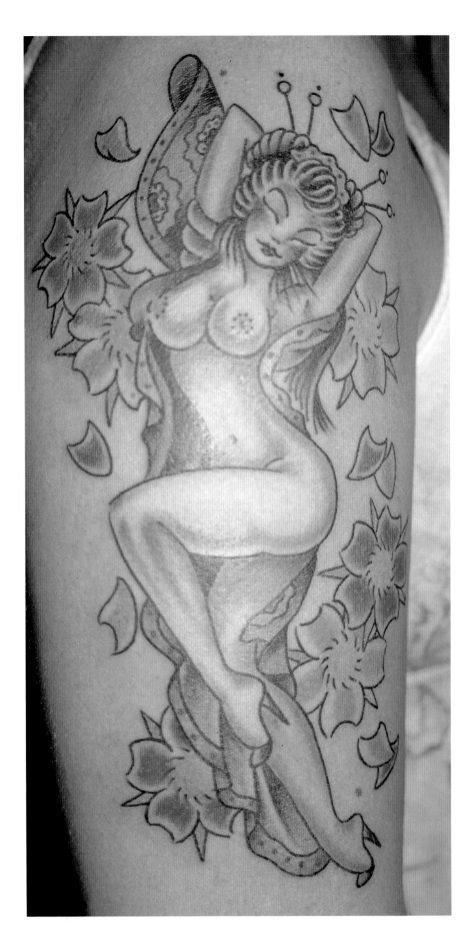

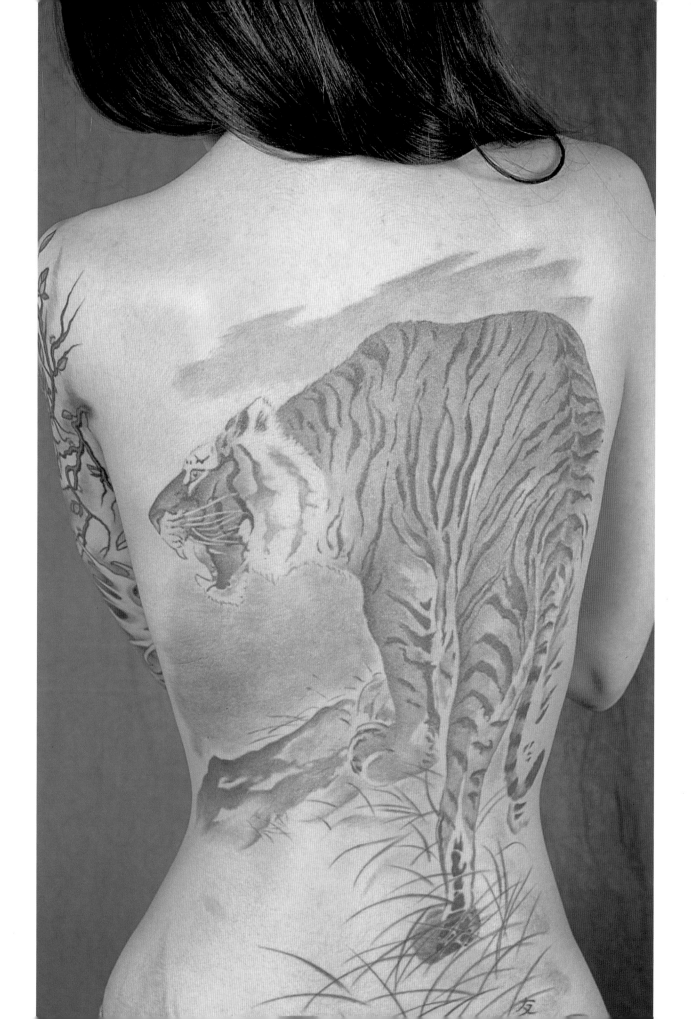

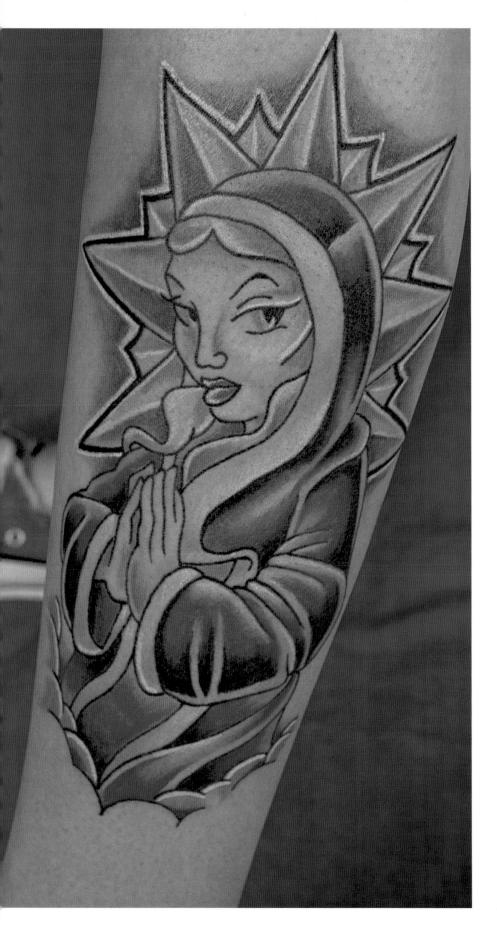

Left: In modern tattooing, traditional religious themes are subverted such as in this cartoon-style tattoo.

interest in drawing. Over the next few years, he took some art classes, and, at age thirty four, he acquired an apprenticeship at Brian Everett's Eternal Tattoo. Being taken under the wing of Tom Renshaw, (one of Bob's best friends and favorite artists), certainly had an influential on Bob as a fledgling tattooist, and he soon created his own niche tattooing black and gray work. Going full circle, back to his boyhood roots, his preference lies in portraiture, especially that of horror related subjects. He regards tattooing as a field where there is always room for improvement and evolution of both style and craft, and therefore tips his hat to artists like Guy Aitchison who are constantly evolving. And with talented newcomers nipping at the heels of established artists, he sees an unlimited potential in the future of tattooing, with the quality of work being steadily pushed to

Right: Amber Phebus tattooed by Kevin Johnson, Ramesses Shadow, Memphis, Tennessee. This is an interesting tattoo in that it consists entirely of color with no outline work at all. Such tattoos appear far more subtle and delicate.

higher and higher levels. Embracing such motivation, he also realizes the fortunate position he is in, being able to make a living from creating art without having an art education background, and doesn't take it for granted; he loves what he does and couldn't imagine doing anything else.

Those profiled here represent a mere fraction of what is happening in the tattoo world today. There are artists who made innovative inroads in tattooing a generation ago who are still around, plying their trade and influencing younger artists. And there are the younger artists themselves, respectful of their elders and the traditions that came along well before they did; learning lessons from the past, drawing inspiration from the world around them today, and laying a course for the future of tattooing.

BEFORE GETTING A TATTOO

"Tattooing is more interesting and beautifying than costly jewelry. It cannot be lost or stolen. Tattooing is something you can keep through life and the only thing you can retain after death."

Brose E. Massy—tattoo artist

It's true, more and more people are getting tattooed each year and the one thing that can be said for all tattoo experiences is that it is a deeply personal event. Whether the design you have chosen is of great personal significance or just a fancy of a purely decorative nature, the result of the experience is with you forever.

Before getting your tattoo, ask yourself if you are positive that this is a commitment you are prepared to make. This may sound obvious but you would be wise to think about the ramifications of having a tattoo. It's not just getting a tattoo that you have to consider, it's the living with it subsequently. Hanging in his parlor, Sailor Jerry kept a list of reasons not to get a tattoo. Number five of seven advised, "people will know you are running your own life, instead of listening to them!"

There are a few points that anyone should consider before they take the first step toward a tattoo.

• Depending on where on the body you are going to place your design, every time you look in the mirror you will see it and it is going to be frequently looked at by others close to you.

• Tattoos commonly provoke adverse reactions from others. Some people will fell compelled to pass comment on your work and not everyone's reactions will be favorable. Not only this, they may make unfounded assumptions about your personality, intelligence, and background. It's human nature to be curious and you may attract unwelcome attention, though on a positive note tattoos are a great talking point and can be a good way to meet people.

• Having decided you want to get tattooed, in our experience you know what you want and where you want it, and no amount of pain,

money, time, or recriminations are going to dissuade you. However, take the time to find an artist that produces the style of work you are looking for. All reputable tattoo studios should be registered with the local authorities and should be a clean and sanitary environment. Personal recommendations are always a good start, but failing that, do your own research. Look at websites, magazines, visit studios, and trawl through as many artists' books as you can get your hands on. Discuss your planned design with the prospective artist, making sure they are comfortable with your requirements and that you in turn are comfortable with them and are confident of their abilities to produce what you want. Keep in mind that you will probably be spending several hours in very close contact with the tattooist and if you don't feel comfortable with them then these hours may feel like a lifetime.

• When discussing your design with a tattooist, if you don't have a specific idea of what you want, bring source material or pictures from books or magazines. This will give the artist a better idea of what you want and make it easier for you to be understood.

• When making an appointment, be aware that most good tattooists are booked weeks and sometimes months in advance. Don't be frustrated or impatient—wait. A few weeks for something you'll have on your skin forever really is worth taking your time over.

• Don't be too specific or inflexible about your tattoo—you must appreciate that you are working with an artist who will interpret what you want to a certain degree from their own perspective and will put a little of themselves into the work. That said, if you are getting custom work done and the artwork is being created by the tattoo artist, do make sure you approve the final draft and if you are not happy with it then feel free to say so.

• When going to get tattooed do make sure you are wearing suitable clothing, something that's not restrictive, bearing in mind you may have to remove some of it so that the artist can work on the area. Blood and ink will stain most fabrics and also you will probably be feeling quite sore by the time you leave the studio, so ensure you will be warm enough and comfortable in what you have to wear to travel home in and that it's not your favorite item of clothing.

• How you feel physically will determine how well you handle the tattooing process. If you are not your normal 100% due to a cold, fatigue, or medication you will feel more discomfort during the tattooing process. It will be better to reschedule an appointment than to go into the shop for a tattoo with a migraine headache. The artist will also appreciate the fact that you decided not to come in with the flu.

• A part of that feeling 100% is your stomach. Many first timers are under the false impression that if you don't eat, you won't have anything to throw up if you get sick. Unfortunately this does more harm than good. Eating prior to getting a tattoo re-energizes your body. It puts back nutrients your body has depleted and returns your blood-sugar level back to normal. Having something in your stomach also helps to calm your nerves.

• Make sure you do not use alcohol or aspirin-based medication, this will thin the blood making you bleed more and thus difficult to tattoo.

• Don't get tattooed if you have a hangover.

• If you have a pre-existing condition, such as diabetes or heart problems, it would be wise for you to consult with your personal physician about your plans to get a tattoo. Don't risk your health.

• Everybody has a different threshold for pain. What will hurt one person can be simply annoying to someone else. How much a tattoo hurts is dependent on your individual tolerance for pain. Having said that there are areas more sensitive than others, and these are the same for everybody. Generally the "meatier" the area, the less it hurts. The closer to bone or tendons, the more it hurts. Likewise certain areas are more frequently exposed to the elements, such as the back and outside parts of the arm, and these tend to hurt less than more protected areas, like the inside of the arm, thigh, or stomach. Women also tend to be more tolerant of pain than men, especially around the stomach area, but be warned—if you are due to be menstruating when you have a tattoo appointment this can affect your usual pain threshold.

• The pain associated with tattooing has been described as feeling like a) a bad sunburn, b) a bee stinging several times, c) a cigarette burn, and d) a bad scrape. In most cases the pain diminishes after a few minutes when

your body's natural pain killers (endorphins) kick in, but be mentally prepared to bear some pain without wriggling.

• There are two generally accepted methods of pricing a tattoo—a flat fee and an hourly fee. Most tattoo studios will have both pricing methods in effect depending on what the shop's policies and requirements are. Here is a description of the two methods:

Flat fee: This is the preferred method of pricing flash and small standards like roses, hearts, and lettering. Pricing is estimated based on what it takes for an artist to complete the piece; length of time, complexity of design, number of colors, etc. Keep in mind that these prices are not set in stone and will fluctuate depending on other circumstances such as placement, resizing, adding and/or omitting elements from the design.

Hourly fee: Most custom artwork will be charged on a shop's hourly rate. This is particularly true when the piece is large, takes more than one sitting to accomplish, or is freehanded on the client. What determines a shop's hourly rate is their operating cost, the artist's time, and the artist's quality and experience.

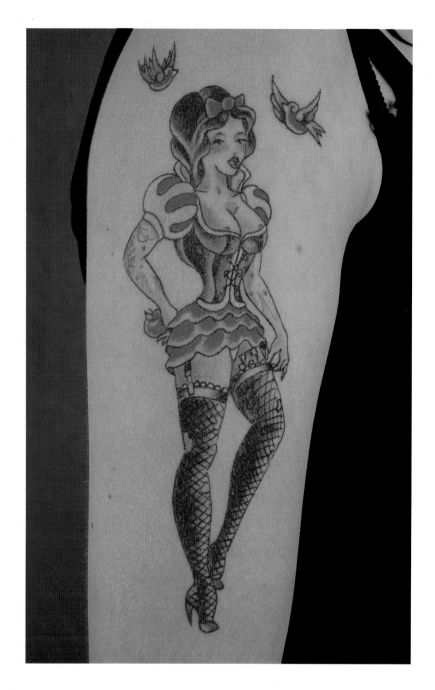

• However a tattoo is priced, be advised that once set, it is generally not a good idea to try to haggle down the price. It belittles the artist and it can make you look like a cheapskate. If you feel the price is genuinely too high, then talk to the artist. If your concerns are legitimate, he may reduce it for you—otherwise look for cheaper alternatives. Also most artists insist on being paid in cash with a deposit up front.

Ultimately, this is about you, and you have to live with the choices you've made… not all of which are so public or permanent. Getting tattooed should be an exciting and positive experience—a unique way of expressing yourself.

INDEX